GRAPHIC STORYTELLING AND VISUAL NARRATIVE

The Will Eisner Library
from W. W. Norton & Company

GRAPHIC STORYTELLING AND VISUAL NARRATIVE

PRINCIPLES AND PRACTICES FROM THE LEGENDARY CARTOONIST

Will Eisner

A Will Eisner Instructional Book

W. W. NORTON & COMPANY
NEW YORK · LONDON

For information about permission to reproduce selections from this book,
write to Permissions, W. W. Norton & Company, Inc.,
500 Fifth Avenue, New York, NY 10110

For information about special discounts for bulk purchases, please contact
W. W. Norton Special Sales at specialsales@wwnorton.com or 800-233-4830

Manufacturing by RR Donnelley, Willard
Book design by Grace Cheong, Black Eye Design, blackeye.com
Production manager: Devon Zahn
Digital production: Sue Carlson, Joe Lops, and Alex Price

Produced in Association with:
The Center for Cartoon Studies
White River Junction, Vermont
cartoonstudies.org

Library of Congress Cataloging-in-Publication Data

Eisner, Will.
[Graphic storytelling]
Graphic storytelling and visual narrative : principles and practices
from the legendary cartoonist / Will Eisner.
p. cm.
Includes bibliographical references.
Originally published in 1996 with the title: Graphic storytelling.
ISBN 978-0-393-33127-1 (pbk.)
1. Comic books, strips, etc.—Authorship. 2. Comic books, strips, etc.—Illustrations.
3. Cartooning—Technique. 4. Graphic novels—Authorship. I. Title.
PN6710.E57 2008
741.5′1—dc22

2008019796

W. W. Norton & Company, Inc., 500 Fifth Avenue, New York, N.Y. 10110
www.wwnorton.com

W. W. Norton & Company Ltd., Castle House, 75/76 Wells Street, London W1T 3QT

7 8 9 0

CONTENTS

viii

Contents

EDITOR'S NOTE

WILL EISNER INTENDED FOR *GRAPHIC STORYTELLING AND VISUAL NARRATIVE* AND HIS other educational/instructional books to be living textbooks with long shelf lives and continuing utility. It is in that spirit that this posthumous W. W. Norton edition, the first by a new publisher, respectfully incorporates additional changes.

The original editions of this book and its first companion volume, *Comics and Sequential Art*, were published by Poorhouse Press, a tiny imprint operated on a very part-time basis by Will Eisner himself, and largely overseen by his late brother Pete, who had retired some years earlier. Ever the ambitious businessman as well as creator, Eisner decided to self-publish his educational titles to keep a foot in all aspects of the comics industry. (*Expressive Anatomy*, the final volume of his educational trilogy, was first published after Eisner's death.)

While Eisner was solely responsible for the editorial side of the Poorhouse Press volumes, all of his numerous graphic novels, magazines and comic books were being published and designed by professional organizations in America and overseas, and he was not, during that stage of his long career, running a true publishing operation himself. Thus, the Poorhouse Press editions, though commercially successful—as dozens of printings attest—were assembled without the benefit of today's sophisticated scanners or professional art direction. Most of the illustrations, including Eisner's own art, were delivered to Poorhouse's printer as mechanical boards comprised of simple Xeroxed paste-ups or less-than-perfect photostats. As a result, the printed version of most images suffered considerably.

For the new W. W. Norton editions, virtually all of the illustrations have been scanned directly from Eisner's archived original art or, in the case of other artists' examples, from the best available source materials. In some cases, altogether new images were used, including alternate images from Eisner's out-takes file. Four sidebars have been added to illustrate storytelling principles by contemporary cartoonists.

In keeping with the author's wishes, we have updated the text, where necessary, to remove anachronisms and to reflect the current state of the comics industry and technology. Minor grammatical errors were corrected and some new text was added for clarity. Additional insightful editing to this edition was provided by Margaret Maloney, with oversight from Robert Weil and Lucas Wittmann. With input from James Sturm of the Center for Cartoon Studies, the various elements were given to Black Eye Design where Michel Vrana, an exceptional designer with long experience in the comics field, worked with talented book designer Grace Cheong to update and improve the layout. The guidance and ultimate approval of the estate, primarily Ann Eisner and Carl and Nancy Gropper, was at all times appreciated. The final results, we are confident, would very much please the author.

Denis Kitchen

—Denis Kitchen

FOREWORD

IN AN EARLIER WORK, *COMICS AND SEQUENTIAL ART*, I ADDRESSED THE PRINCIPLES, concept and anatomy of the comics form, as well as the fundamentals of the craft. In this work, I hope to deal with the mission and process of storytelling with graphics.

The effort of artists to tell stories of substance with imagery is not new. In an essay in *Bookman's Weekly* (July 1995) David Beronä reviewed some of the history of this effort. He cited major woodcut artists who, in my opinion, established an historical precedent for modern graphic storytelling. Frans Masereel, a Belgian political cartoonist for *La Feuille*, began producing "novels without words." In 1919 he published *Passionate Journey*, a novel told in 169 woodcuts, last published by Penguin Press, New York, 1988. This book has an introduction by Thomas Mann. The famous author enjoins the reader to accept being "captivated by the flow of the pictures and...the deeper purer impact than you have ever felt before." Masereel went on to create more than twenty "novels without words." He was followed by Otto Nückel, a German, whose *Destiny*, a novel in pictures, appeared in 1930, published in America by Farrar & Rinehart.

About that time, Lynd Ward also began publishing graphic novels in woodcut form. He dealt with man's spiritual journey through life. In six succeeding books, Ward firmly establishes the architecture of the form. Of greater significance is the resonance of the subjects he undertook. It is these substantial themes that provide encouragement to the aspirations of comics. A sampling of Ward's work is included in this book.

In 1930, Milt Gross, the brilliant American cartoonist, produced a satirical graphic novel, *He Done Her Wrong*. It was a spoof of the classic novel done with wordless cartoons. While he didn't have the literary pretensions, or the serious subject intent, of Masereel, Nückel, or Ward, he nevertheless observed the same format. In 1963, it was reprinted in pocket book format by Dell Books. By then, comic books were well established. My colleague Harvey Kurtzman broke additional ground in this area with his paperback of all-new comics, *Jungle Book*, in 1959.

Comics are essentially a visual medium composed of images. While words are a vital component, the major dependence for description and narration is on universally understood images, crafted with the intention of imitating or exaggerating reality. The result is often a preoccupation with graphic elements. Page layout, high-impact effects, startling rendering techniques and mind-blowing color can monopolize the creator's attention. The effect of this is that the writer and artist are deflected from the discipline of storytelling construction and become absorbed in a packaging effort. The graphics then *control* the writing and the product descends into little more than literary junk food.

Despite the high visibility and attention that artwork compels, I hold that the story is the most critical component in a comic. Not only is it the intellectual frame on which all artwork rests, but it, more than anything else, helps the work endure. This is a daunting challenge to a medium that has a history of being considered juvenile pap. The task is further compounded by the harsh reality that images and packaging elicit the primary reader response. Nevertheless, the comics medium is a literary/art form, and as it matures, it aspires to recognition as a "legitimate" medium.

The traditional production of comics by a single individual has, over the years, given way to the dominance of teams (writer, artist, inkers, colorists and letterers). While the artist/writer assumes the total storytelling responsibility, the team, on the whole, is involved and must feel connected to the articulation of the story. Writing, as I use it in comics, is not confined to the employment of words. Writing in comics includes all the elements in a seamless mix and becomes part of the mechanics of the art form.

In *Graphic Storytelling*, the concentration is on a basic understanding of narration with graphics. This book will undertake the examination of storytelling and review the fundamentals of its application in the comics medium.

—Will Eisner

ACKNOWLEDGMENTS

THIS BOOK OWES ITS EXISTENCE TO THE STUDENTS AT THE SCHOOL OF VISUAL ARTS IN New York who attended my classes in Sequential Art over eighteen years. Their pursuit of excellence and interest in the medium helped focus my attention on storytelling and its role in this literary/art form.

To Dave Schreiner, my gratitude for his skillful and patient editing. His years of experience in comic books has been an invaluable aid.

To my wife, Ann, who contributed many hours of logistical support, my appreciation for her interest and endurance.

To my son, John, who provided much of the underlying research needed to buttress the postulations common to a book of this kind, my thanks.

To supportive colleagues, Neil Gaiman, Scott McCloud, Tom Inge, and Lucy Caswell, who generously took the time to read the early "dummy" and provide me with thoughtful opinions and advice, my gratitude.

xiii

INTRODUCTION

IN OUR CULTURE, FILM AND COMICS ARE THE MAJOR CONVEYORS OF STORY THROUGH imagery. Each employ arranged graphics and text or dialogue. While film and theater have long ago established their credentials, comics still struggle for acceptance, and the art form, after more than a century of popular use, is still regarded as a problematic literary vehicle.

The latter half of the twentieth century experienced an alteration in the definition of literacy. The proliferation of the use of images as a communicant was propelled by the growth of a technology that required less in text-reading skills. From road signs to mechanical use instructions, imagery aided words, and at times even supplanted them. Indeed, visual literacy has entered the panoply of skills required for communication. Comics are at the center of this phenomenon.

The rise and establishment in America of this remarkable reading form in the package we know as comic books occurred over sixty years. From the compilation of pre-published newspaper comic strips, comic book material quickly evolved into complete original stories and then into graphic novels. This last permutation has placed more of a demand for literary sophistication on the artist and writer than ever before.

Since comics are easily read, their reputation for usefulness has been associated with people of low literacy and limited intellectual accomplishment. And, in truth, for decades the story content of comics catered to that audience. Many creators are still content with furnishing little more than titillation and mindless violence. Little wonder that encouragement and acceptance of this medium by the education establishment was for a long time less than enthusiastic.

The predominance of art in the traditional comics format brought more attention to that form than to its literary content. It is hardly surprising, therefore, that comics as a reading form was always assumed to be a threat to literacy, as literacy was traditionally defined in the era before film, television and the Internet.

In their influential book *The Medium Is the Massage*, Marshall McLuhan and Quentin Fiore point out that "societies have always been shaped more by the nature of the media by which men communicate than by the content of the communication." This has been the fate of the comics. Its colorful and pictorial format bespoke of simple content.

The years between 1967 and 1990 saw comics beginning to reach for literary content. It started with the confrontational underground movement of artists and writers riding a wave of direct distribution to the market. This was followed by a mushrooming of comic book stores which supplied easy access to a broader spectrum of readers. It was the beginning of the maturation of the medium. At last, comics sought to deal with subject matter that had been regarded as the

province of text, live theater or film. Autobiography, social protest, reality-based human relationships and history were some of the subjects now undertaken by comics. The graphic novel that addressed "adult" subjects proliferated. The average age of readers rose. The market for innovation and mature subject matter expanded. Accompanying these changes, a more sophisticated group of creative talents became attracted to the medium and raised its standards.

In this environment, the comic book suffered from the comments of literary critics who found it problematic to determine whether comics could properly deal with serious subjects. This general attitude adversely affected the climate of acceptance.

This epitomizes the challenge facing comic book writers and artists seeking a place in our literary culture. How far comics can go in addressing "serious themes" is an ongoing challenge. Fortunately, the increase in the number of serious artists and writers attracted to comics as a career is testimony to the medium's potential. And it is my conviction that story content will be the propellant of the future of the comic books.

With the beginning of the 1990s, the new literacy became more evident in our Western culture, and as Paul Gravett of the *London Daily Telegraph* observed, "There seems to be no limit to the [comics] medium's ambitions.... Those accustomed to scanning regular columns of type often have difficulty assimilating the haphazard captions in comics at the same time as jumping from image to image. But to a young generation brought up with television, computers and video games, processing verbal and visual information on several levels at once seems natural, even preferable."

COMICS AS A MEDIUM

Reading in a purely textual sense was mugged on its way to the twenty-first century by the electronic and digital media, which influenced and changed how we read. Printed text lost its monopoly to another communication technology, film. Aided by electronic transmission, it became the major competitor for readership. With its limited demand on a viewer's cognitive skills, film makes the time-consuming burden of learning to decode and digest words seem obsolete. Film viewers experience countless lifelike incidents of ordained duration as they watch a screen where artificial situations and contrived solutions become integrated into their mental inventory of memories retained from real life experience.

Film actors are more "real" than people created within text. Most important, watching film establishes a rhythm of acquisition. It is a direct challenge to static print. Accustomed to the pace of film, readers grow impatient with long text passages because they have become used to acquiring stories, ideas and information quickly and with little effort. As we know, complex concepts become more easily digested when reduced to imagery. Printed communication as a portable source of ideas in depth, nevertheless remains a viable and necessary medium. In fact it responds to the challenge of electronic media by merger. A partnership of words with imagery becomes the logical permutation. The resulting configuration is called comics and it fills a gap between print and film.

In his fine book *Understanding Comics*, Scott McCloud aptly described comics as "a vessel which can hold any number of ideas and images." In a wider view we must consider this vessel as a communicator. It is in every sense a singular form of reading.

The reading process in comics is an extension of text. In text alone the process of reading involves word-to-image conversion. Comics accelerates that by providing the image. When properly executed, it goes beyond conversion and speed and becomes a seamless whole. In every sense, this misnamed form of reading is entitled to be regarded as literature because the images are employed as a language. There is a recognizable relationship to the iconography and pictographs of logographic (or character-based) writing systems, like Chinese *hanzi* or Japanese *kanji*.

When this language is employed as a conveyance of ideas and information, it separates itself from mindless visual entertainment. This makes comics a storytelling medium.

NOTE Throughout this book, I use certain terms which ought to be defined and distinguished from one another. They are:

> **GRAPHIC NARRATIVE:** A generic description of any story that employs image to transmit an idea. Film and comics both engage in graphic narrative.
> **COMICS:** A form of sequential art, often in the form of a strip or a book, in which images and text are arranged to tell a story.
> **STORYTELLER:** The writer or person in control of the narration.
> **SEQUENTIAL ART:** Images deployed in a specific order.

GRAPHIC STORYTELLING AND VISUAL NARRATIVE

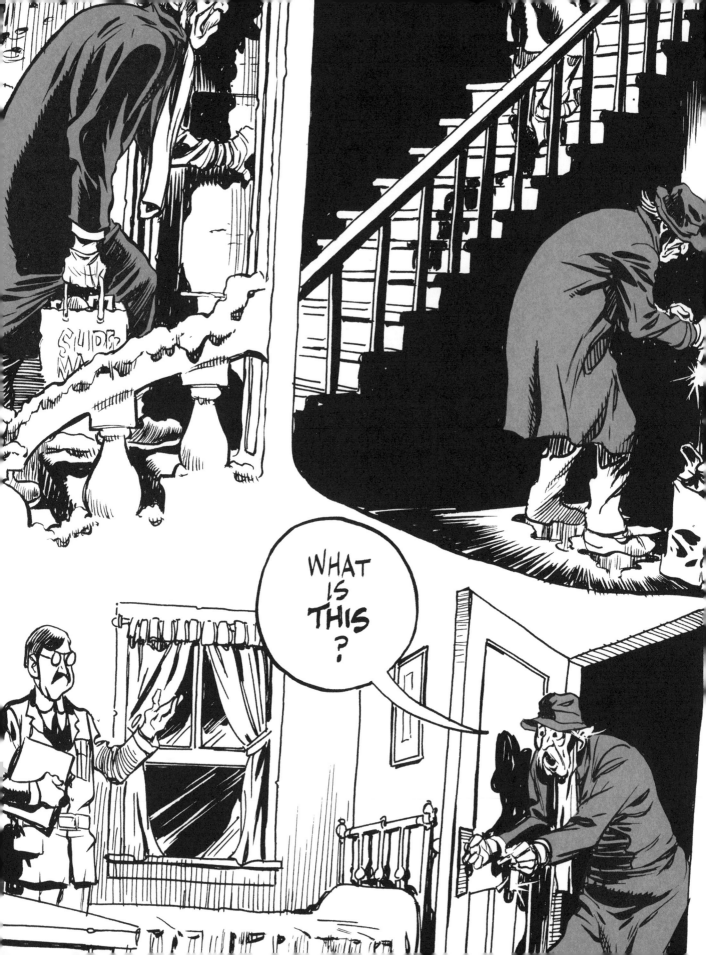

CHAPTER 1

THE STORY OF STORYTELLING

The telling of a story lies deep in the social behavior of human groups—ancient and modern. Stories are used to teach behavior within the community, to discuss morals and values, or to satisfy curiosity. They dramatize social relations and the problems of living, convey ideas or act out fantasies. The telling of a story requires skill.

In primitive times, the teller of stories in a clan or tribe served as entertainer, teacher and historian. Storytelling preserved knowledge by passing it from generation to generation. This mission has continued into modern times. The storyteller must first have something to tell, and then must be able to master the tools to relay it.

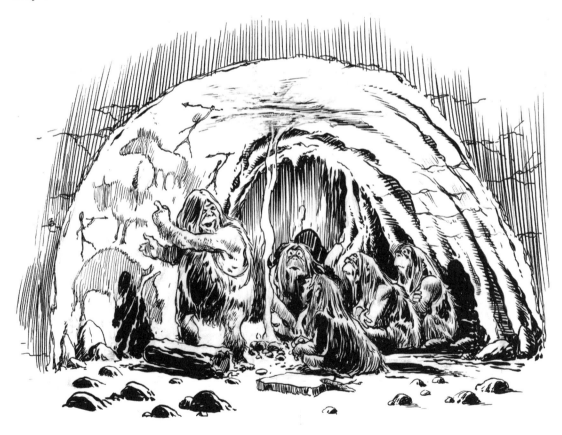

The earliest storytellers probably used crude images buttressed with gestures and vocal sounds which later evolved into language. Over the centuries, technology provided paper, printing machines and electronic storage and transmission devices. As these developments evolved, they affected the narrative arts.

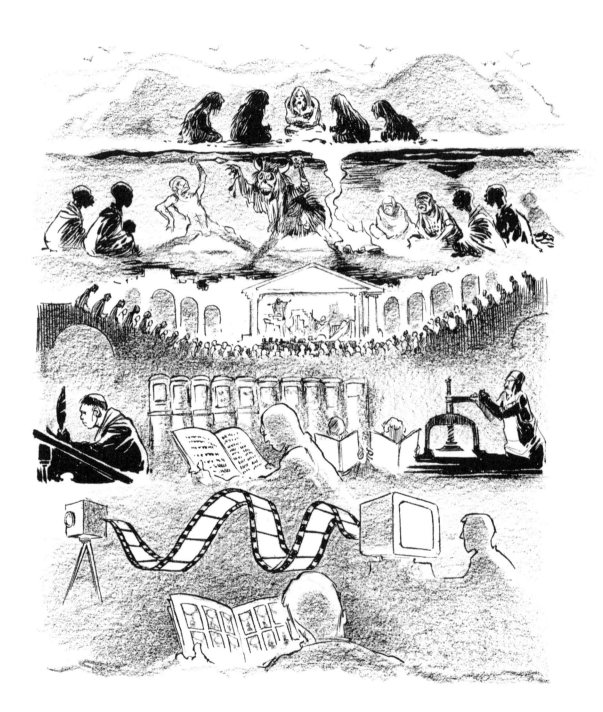

CHAPTER 2

WHAT IS A STORY?

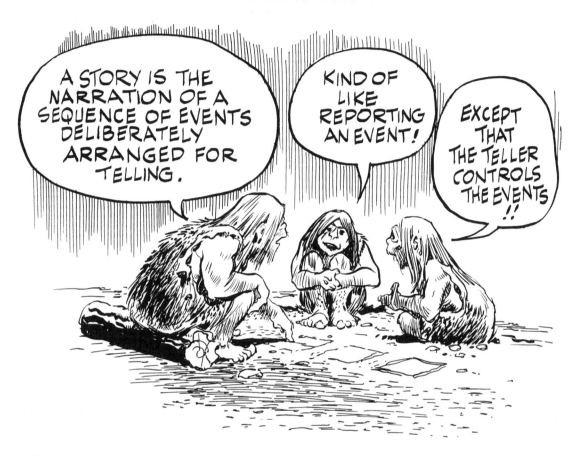

All stories have a structure. A story has a beginning, an end, and a thread of events laid upon a framework that holds the two together. Whether the medium is text, film or comics, the skeleton is the same. The style and manner of its telling may be influenced by the medium but the story itself abides.

The structure of a story can be diagrammed with many variations, because it is subject to different patterns between its beginning and end. A structure is useful as a guide to maintaining control of the telling.

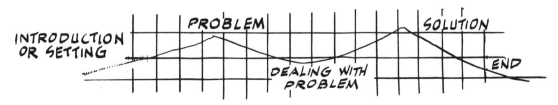

Before a story is composed, it exists in the abstract. At this point, it is still a lot of thoughts, memories, fantasies and ideas, floating around in one's head, waiting for a structure.

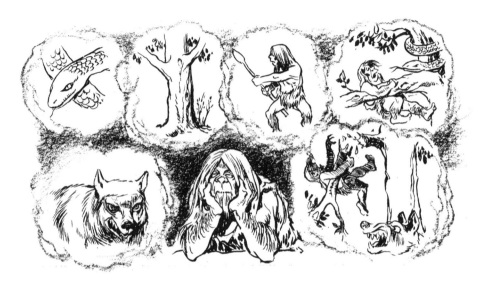

It becomes a story when told in an arranged and purposeful order. The basic principles of narration are the same whether told orally or visually.

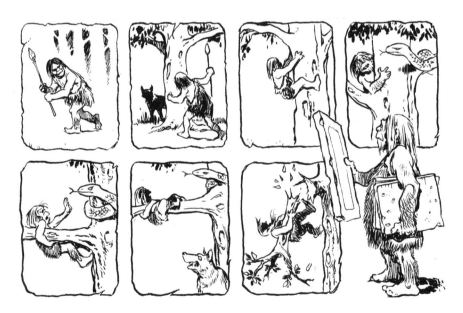

THE FUNCTION OF A STORY

The story form is a vehicle for conveying information in an easily absorbed manner. It can relate very abstract ideas, science, or unfamiliar concepts by the analogous use of familiar forms or phenomena.

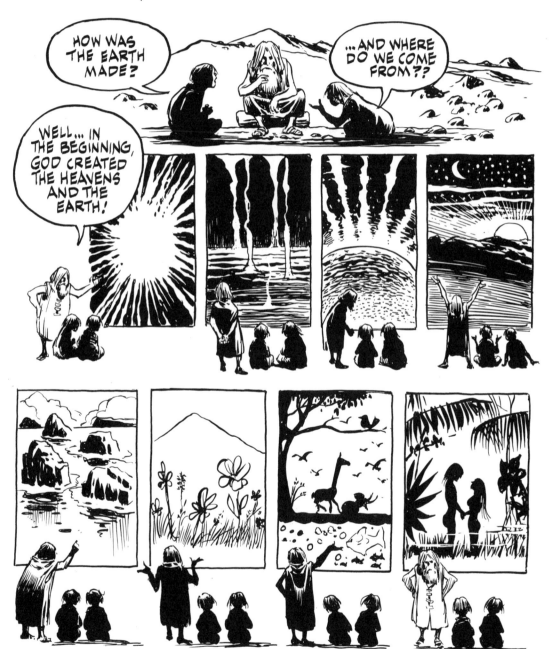

CHAPTER 3

TELLING A STORY

There are different ways of telling a story. Technology provides many vehicles of transmission, but fundamentally there are only two major ways: words (oral or written) and images. Sometimes the two are combined.

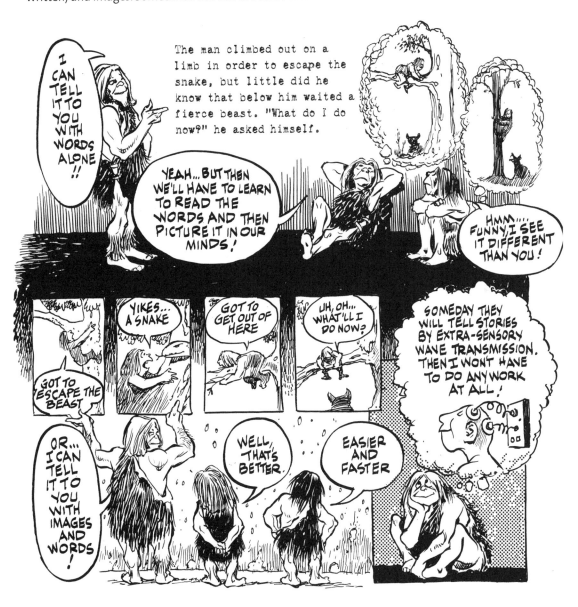

STORIES TOLD WITH PRINT

Through the first half of the twentieth century, print dominated as a vehicle of communication. While film and the Internet have challenged its superiority, print will nevertheless maintain its importance. Stories told with graphic narration must deal with transmission. This has an influence on the manner in which the story is told and will influence the story itself. It is at this point that the story-teller comes in contact with the marketplace.

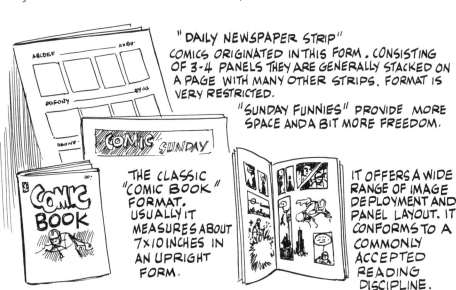

"DAILY NEWSPAPER STRIP"
COMICS ORIGINATED IN THIS FORM. CONSISTING OF 3-4 PANELS THEY ARE GENERALLY STACKED ON A PAGE WITH MANY OTHER STRIPS. FORMAT IS VERY RESTRICTED.

"SUNDAY FUNNIES" PROVIDE MORE SPACE AND A BIT MORE FREEDOM.

THE CLASSIC "COMIC BOOK" FORMAT. USUALLY IT MEASURES ABOUT 7×10 INCHES IN AN UPRIGHT FORM.

IT OFFERS A WIDE RANGE OF IMAGE DEPLOYMENT AND PANEL LAYOUT. IT CONFORMS TO A COMMONLY ACCEPTED READING DISCIPLINE.

Readers and viewers identify content with its package. Comics readers expect printed comics to come in a familiar package. A story told in an unconventional format may be perceived differently. The format has an important influence in graphic storytelling.

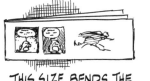

THIS SIZE BENDS THE TELLING TO A HORIZONTAL FORMAT. VERTICAL ACTION EFFECTS ARE INHIBITED.

THIS FORMAT RESTRICTS THE TELLER TO A VERTICAL FIELD. IT AFFECTS GRAPHIC STORYTELLING BY NARROWING THE FLOW OF IMAGERY.

STORIES TOLD WITH IMAGERY

For the purpose of this discussion, an "image" is the memory or idea of an object or experience recorded by a narrator either mechanically (photography) or by hand (drawing). In comics, images are generally impressionistic. Usually, they are rendered with economy in order to facilitate their usefulness as a language. Because experience precedes analysis, the intellectual digestive process is accelerated by the imagery provided by comics.

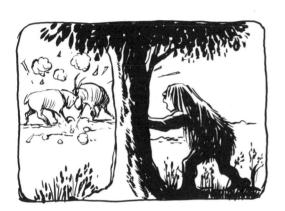
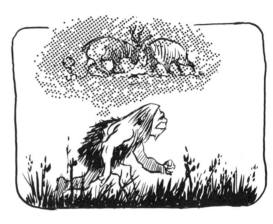

Imagery used as a language has some drawbacks. It is the element of comics that has always provoked resistance to its acceptance as serious reading. Critics also sometimes accuse it of inhibiting imagination.

Static images have limitations. They do not articulate abstractions or complex thought easily. But images define in absolute terms. They are specific.

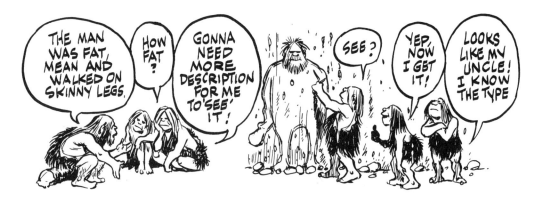

Images in print or film transmit with the speed of sight.

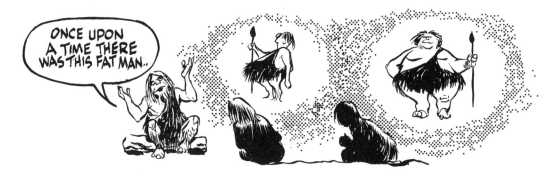

CHAPTER 4

IMAGES AS NARRATIVE TOOLS

STEREOTYPICAL IMAGES

A *stereotype* is defined as an idea or character that is standardized in a conventional form, without individuality. As an adjective, *stereotypical* applies to that which is hackneyed. Stereotype has a bad reputation not only because it implies banality but because of its use as a weapon of propaganda or racism. Where it simplifies and categorizes an inaccurate generalization, it can be harmful, or at the least offensive. The actual word comes from the method used to mold duplicate plates in letterpress printing. These definitions notwithstanding, the stereotype is a fact of life in the comics medium. It is an accursed necessity—a tool of communication that is an inescapable ingredient in most cartoons. Given the narrative function of the medium, this should not be surprising.

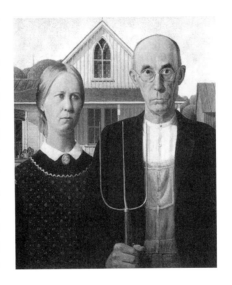

Grant Wood, *American Gothic*, 1930, oil on beaver board, 30 11/16" x 25 11/16", unframed. Friends of American Art Collection, 1930-934, photograph by Bob Hashimoto, The Art Institute of Chicago

Comic book art deals with recognizable reproductions of human conduct. Its drawings are a mirror reflection, and depend on the reader's stored memory of experience to visualize an idea or process quickly. This makes necessary the simplification of images into repeatable symbols. Ergo, stereotypes.

In comics, stereotypes are drawn from commonly accepted physical characteristics associated with an occupation. These become icons and are used as part of the language in graphic storytelling.

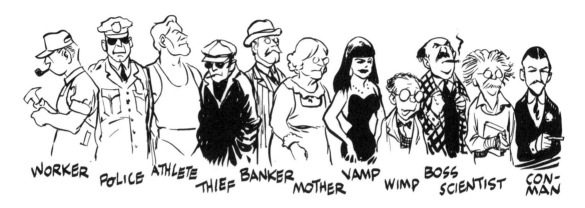

WORKER POLICE ATHLETE THIEF BANKER MOTHER VAMP WIMP BOSS SCIENTIST CON-MAN

In film, there is plenty of time to develop a character within an occupation. In comics, there is little time or space. The image or caricature must settle the matter instantly.

For example, in creating a doctor prototype, it is useful to adopt a compound of characteristics that the reader will accept. Usually this image is drawn from both social experience and what the reader thinks a doctor ought to look like.

Where the plot is arranged to support it, the standardized "doctor look" can be abandoned in favor of a type suitable to the story environment.

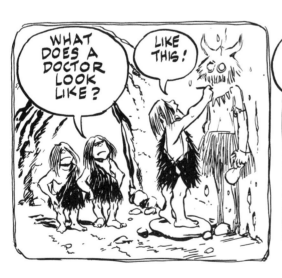

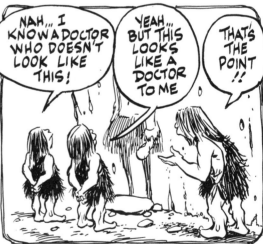

The art of creating a stereotypical image for the purpose of storytelling requires a familiarity with the audience and a recognition that each society has its own ingrained set of accepted stereotypes. But there are those that transcend cultural boundaries.

The comics' creator can now count on a global distribution of his work. To communicate well, the storyteller must be conversant with what is universally valid.

STANDARDS OF REFERENCE

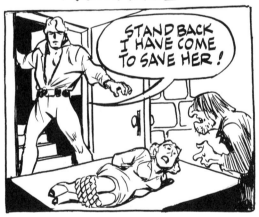

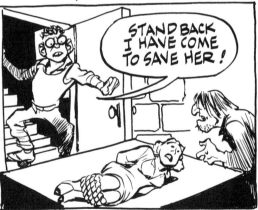

Certain human characteristics are recognizable by physical appearance. In each of the above, the reader evokes a message out of the stereotypical image. In this example, the stereotype of a strong man reinforces romantic believability while an incongruity that provokes humor is conveyed by using a stereotype of a nerd.

In devising actors, it is important to understand why the use of commonly accepted types can evoke a viewer's reflexive response. I believe that modern humans still retain instincts developed as primordial creatures. Possibly the recognition of a dangerous person or responses to threatening postures are residual memories of a primitive existence. Perhaps in the early experience with animal life, people learned which facial configurations and postures were either threatening or friendly. It was important for survival to recognize instantly which animal was dangerous.

There is evidence of this in the successful readability of animal-based images which comics commonly employs when seeking to evoke character recognition.

In graphic storytelling, there is little time or space for character development. The use of these animal-based stereotypes speeds the reader into the plot and helps the storyteller gain the reader's acceptance for the action of his characters.

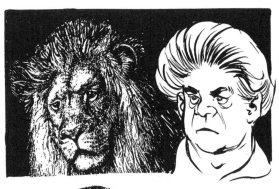

BY EMPLOYING CHARACTERS WHO RESEMBLE ANIMALS, THE GRAPHIC STORYTELLER CAPITALIZES ON A RESIDUE OF HUMAN PRIMORDIAL EXPERIENCE TO PERSONIFY ACTORS QUICKLY.

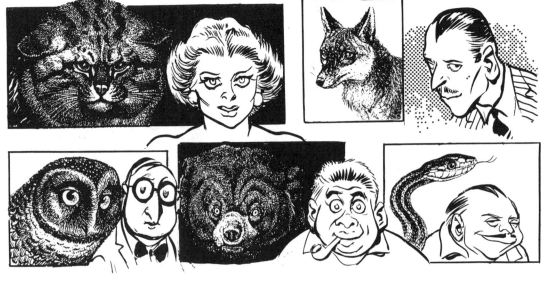

SYMBOLISM

Just as stereotype employs images of people who can be easily identified in comics or film, objects have their own vocabulary in the visual language of comics.

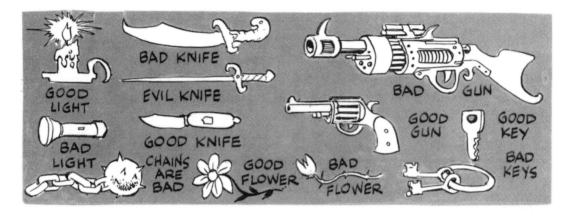

There are some objects which have instant significance in graphic storytelling. When they are employed as modifying adjectives or adverbs, they provide the storyteller with an economical narrative device.

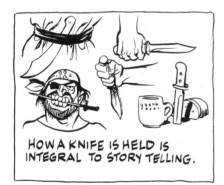

HOW A KNIFE IS HELD IS INTEGRAL TO STORY TELLING.

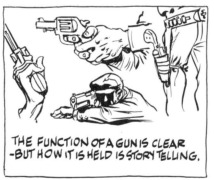

THE FUNCTION OF A GUN IS CLEAR —BUT HOW IT IS HELD IS STORY TELLING.

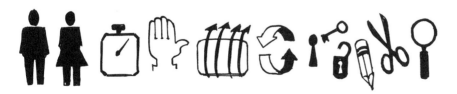

Computers often use symbols to instruct their operators. These are derived from objects familiar to people in a technical society.

Apparel is symbolic. It can tell instantly the strength, character, occupation and intent of its wearer. How it is worn may also convey a signal to the reader.

In comics, as in film, symbolic objects not only narrate but heighten the emotional reaction of the reader.

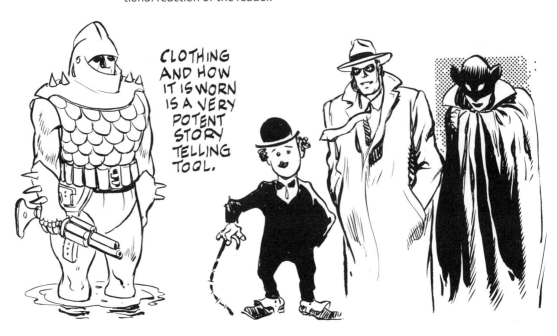

CLOTHING AND HOW IT IS WORN IS A VERY POTENT STORY TELLING TOOL.

In this story, the selection of a doll and broken signs evoke sympathy because they are commonly identified with non-combatants. Left lying in the snow broken and abandoned, they not only testify to the innocence of the victims, but solicit the reader's condemnation of the killers.

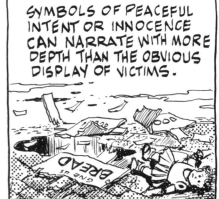

SYMBOLS OF PEACEFUL INTENT OR INNOCENCE CAN NARRATE WITH MORE DEPTH THAN THE OBVIOUS DISPLAY OF VICTIMS.

CHAPTER 5

ALL KINDS OF STORIES

A wide range of stories can be told in the graphic medium but the method of telling a story must be specific to its message.

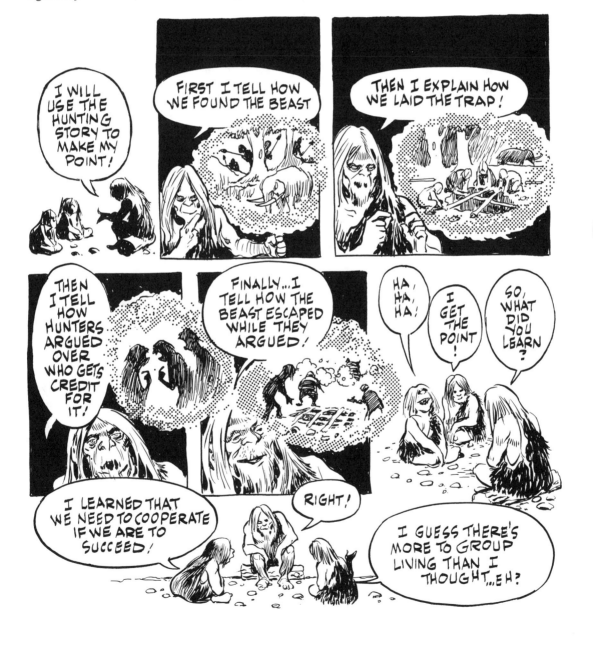

A process is most easily taught when it is wrapped in an interesting "package" ...a story, for example. As comics demonstrated the capacity to marshal technical elements in a disciplined order, they found ready patronage.

This demonstrates the order of thinking when an instructional comic is created.

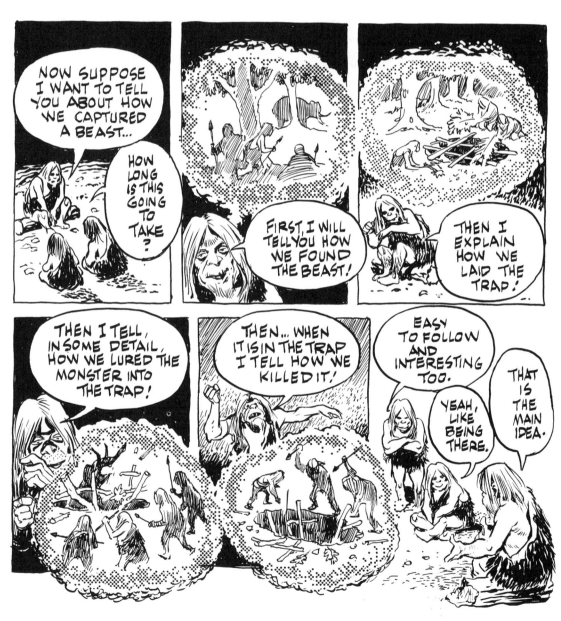

Stories that seek to teach something are usually structured to center on the process. Skills are learned by imitation.

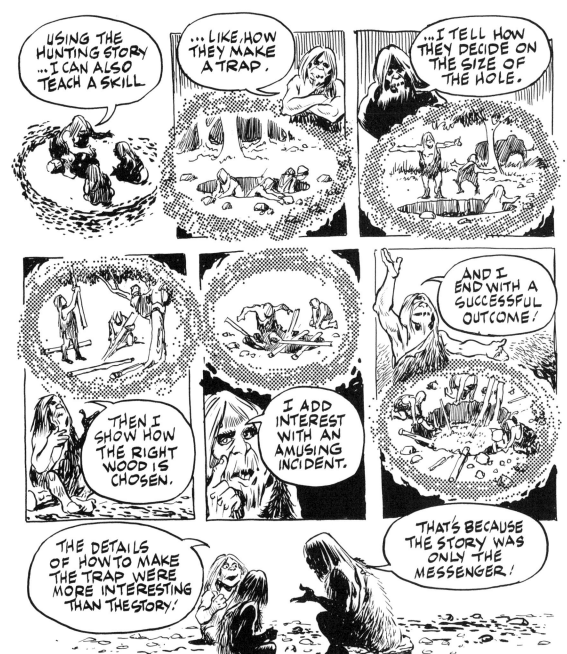

"A PROCESS IS MOST EASILY TAUGHT WHEN IT IS WRAPPED IN AN INTERESTING 'PACKAGE.' "

KEVIN HUIZENGA EMPLOYS A UNIQUE APPROACH TO CARTOONING TO REFLECT ON everything from death to God to African refugees. While many cartoonists' stories are primarily concerned with character and plot, what most interests Huizenga is the way the various elements that make up a comic are diagrammed on the page and how the reader processes that information.

Huizenga once worked for a company where he was responsible for creating visual explanations and diagrams. This work had a direct impact on his comics. In this piece, created for the Center for Cartoon Studies, Huizenga boils down the essential steps of putting together a comic book. Huizenga's style, reminiscent of old-time newspaper comics, is easy to read and directly relates to the subject he's addressing—cartooning.

MAKING A COMIC BOOK

Creating books is at the heart of The Center for Cartoon Studies's rigorous curriculum. CCS's purpose is to create the optimal environment where good comics have a chance of getting made and read. Students are assisted by CCS instructors and visiting artists who are seasoned cartoonists, writers, and designers. At CCS you will immediately jump into the work of producing comics, zines, posters, and various publications. Most importantly, during the solitary, painstaking work of making a comic, CCS students are inspired by one another.

TELLING THE "PLOTLESS" STORY

When high-tech layout and visual pyrotechnics dominate a comic, the result is often a very simple plot.

To a reader interested in the excitement of graphic effects or bravura art, this is quite enough. In fact, a plot with too much "density" can be an impediment. In order to successfully satisfy this, the artist requires from the writer little more than a plot that centers on a single problem, as in plots that center on pursuit or acts of vengeance. Most often, the solution is so uncomplicated, violent action and *special effect* art must sustain interest. The art becomes the story, as in tapestries.

During the mid-1970s, propelled and enabled by great advances in printing and reproduction technology, the illustrated story attracted the interest of comic book artists, writers and publishers. This format was not new, but its renaissance offered highly skilled illustrators and sophisticated writers a compatible vehicle.

In this form of graphic storytelling, the writer and artist retain their sovereignty because the story comes from the text and is embellished by the art. The leisurely rhythm of this kind of graphic storytelling allows the reader time to dwell on the art alone, which is mainly concerned with itself. The artist can freely use oil, water-color, wood engravings or manipulated photography. The skill demands of these techniques are often so great that the art might overwhelm the story.

In the marketplace, however, it makes for a very attractive package and conforms to the traditional idea of a book.

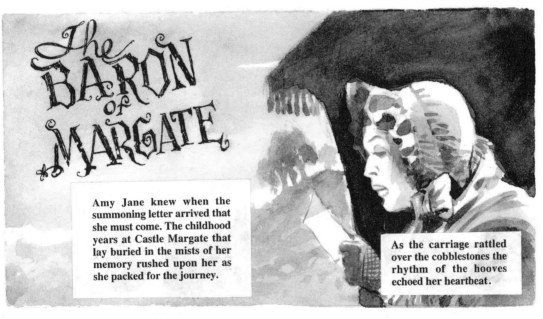

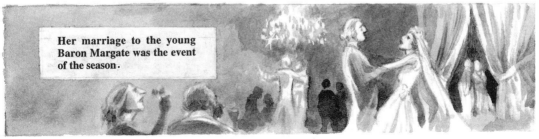

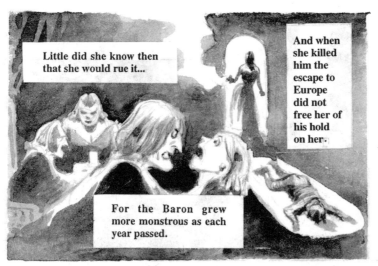

Little did she know then that she would rue it...

For the Baron grew more monstrous as each year passed.

And when she killed him the escape to Europe did not free her of his hold on her.

So Amy returned, drawn to it by some strong, magnetic force.

The castle stood alone, steeped in a shroud of evil spawned centuries ago. Amy's new life at Margate was uneventful until one day a cold wind seeped into her chamber.

She knew...

The time had come.

...out of the dank darkness of the castle's corridors stepped the nobleman of the night ...

The cry was muffled and the deed done with the swift certainty of a curse fulfilled!

Margate Castle remains the dark dominion of its undead 'Black Baron'.

24

Graphic Storytelling and Visual Narrative

In this story, the fulcrum of the plot is two symbols, a daisy and a spiked ball. These symbols serve to establish the premise within symbolic plot and characters.

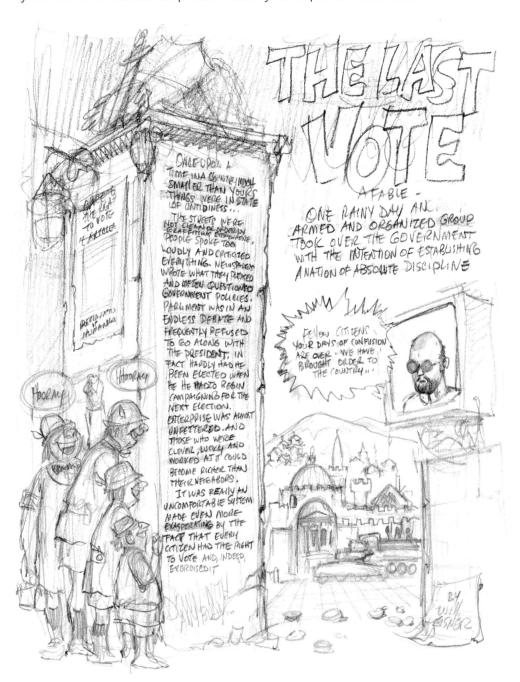

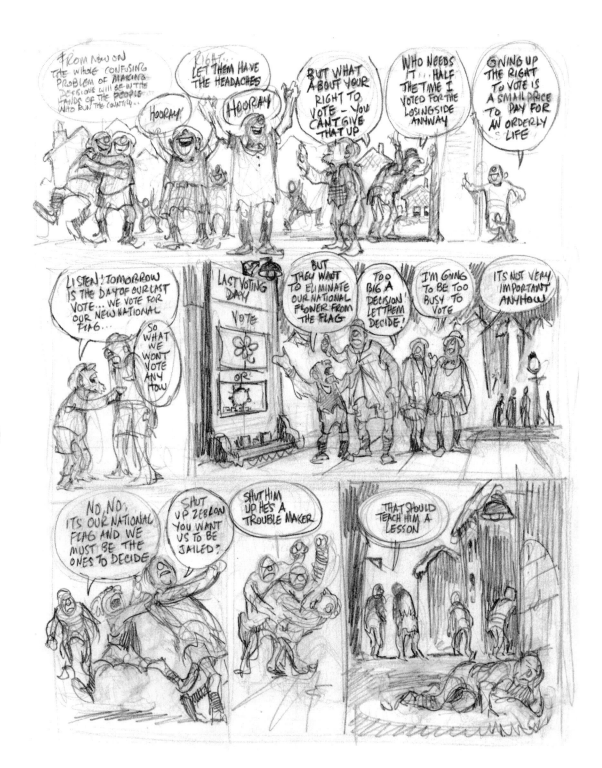

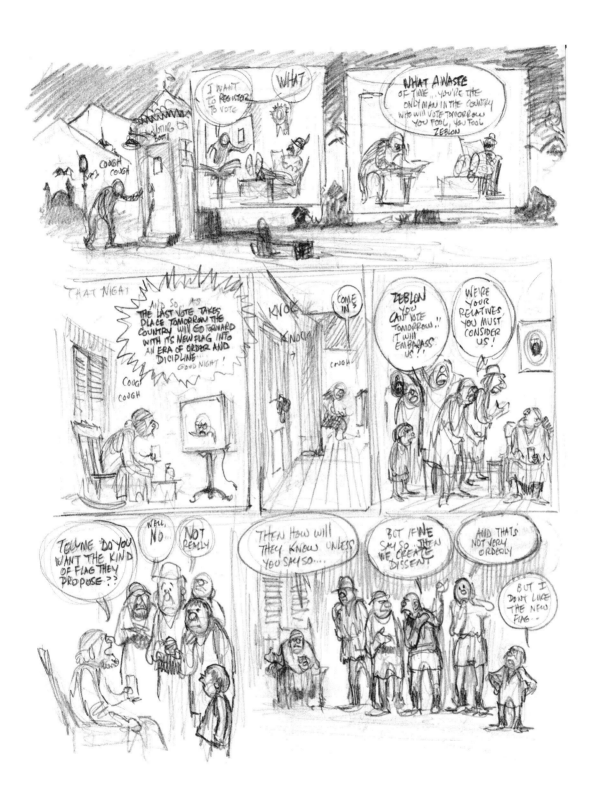

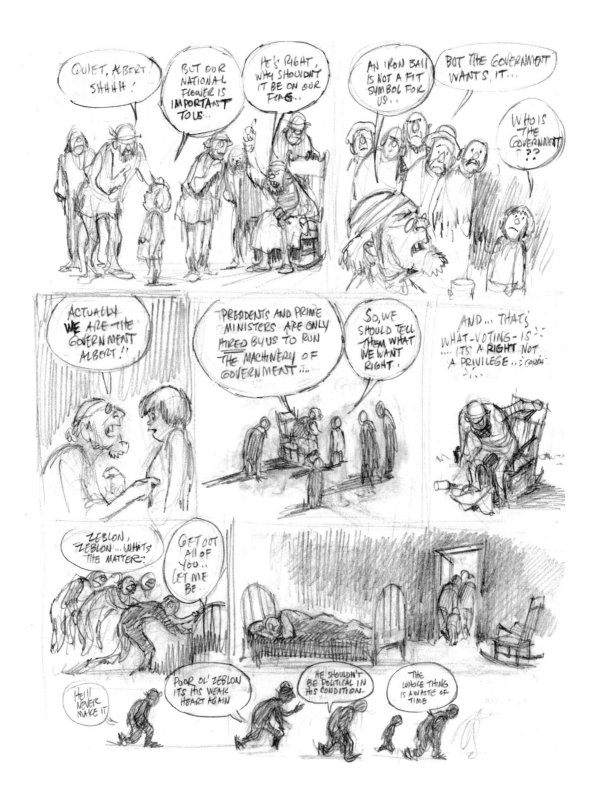

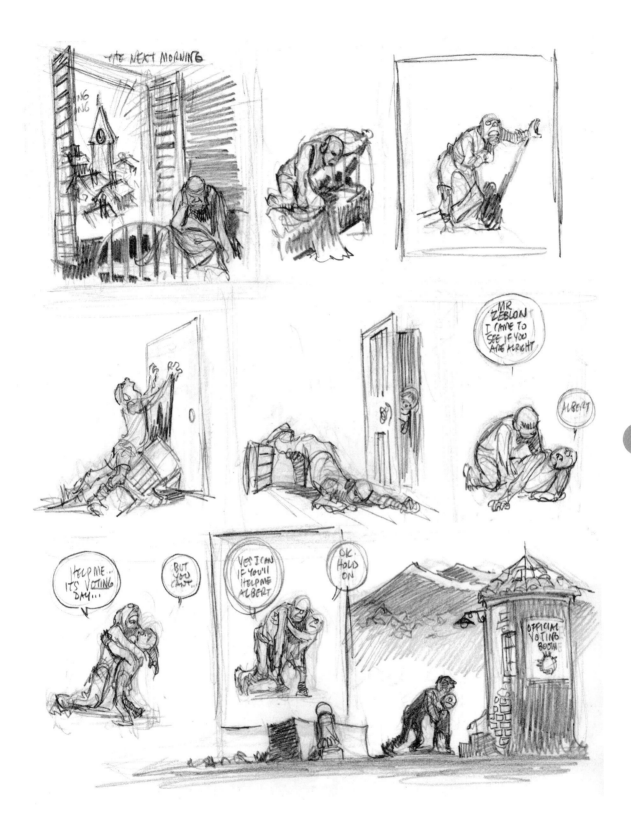

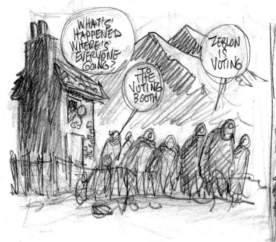
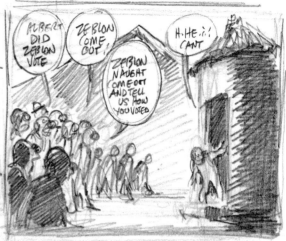
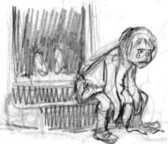

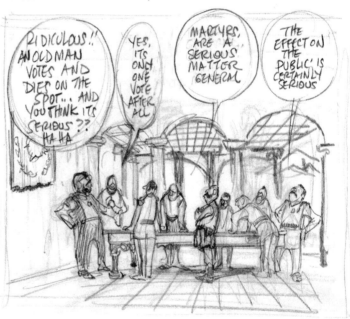

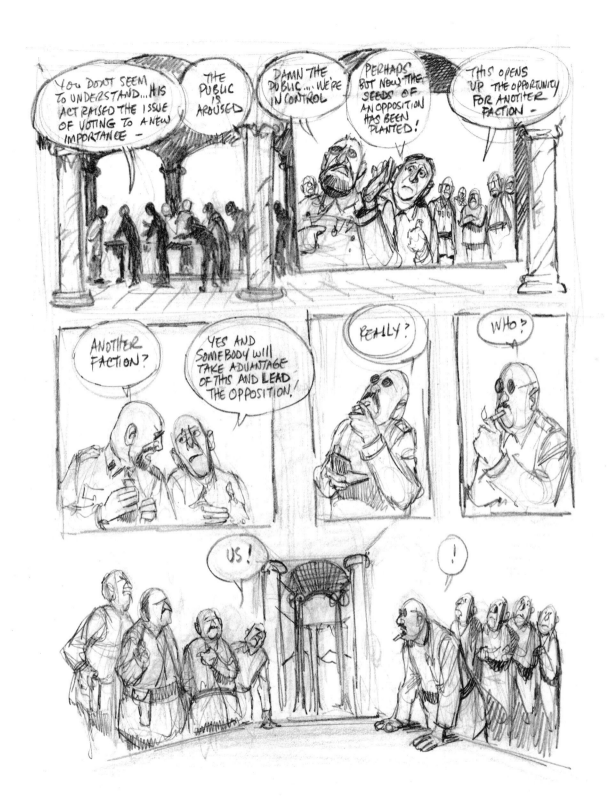

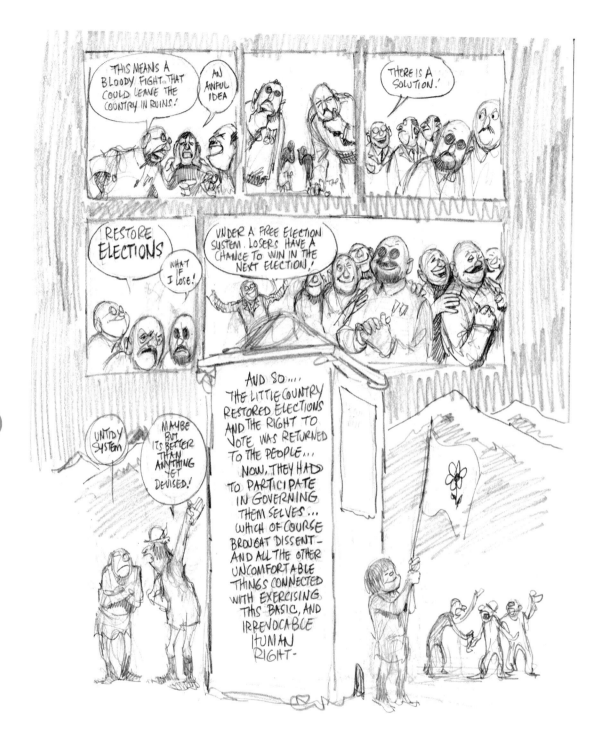

TELLING THE SLICE-OF-LIFE STORY

A slice-of-life story generally extracts an interesting segment from human experience and examines it realistically.

The storyteller selects an event of interest which can stand alone. The writer counts on the life experience or the imagination of the reader to supply the impact of the story. The reader's appreciation hinges on the telling of it. It requires that the artist portrays believable acting. Since characters are dealing with internal emotions, subtle postures and gestures must be true-to-life, instantly recognizable. Powerhouse layouts or excessive rendering technique, which can overwhelm and distract the reader and dominate the story, are counter-productive in this form.

Below are the critical elements of a story that are never made explicit to the reader. In the story that follows, they are implied and are an invisible part of the narrative.

WHAT HAPPENED BEFORE

PRITZIK STARTED OUT (WITH HIS WIFE'S MONEY) PEDDLING DRESSES... SOON HE MADE ENOUGH MONEY TO START UP!

HE OPENED HIS OWN COMPANY BUT WITH LIMITED CAPITAL HE COULD ONLY HIRE LOW GRADE WORKERS

SO IT WAS A NEVER ENDING STRUGGLE TO SURVIVE... IT MADE PRITZIK A BITTER MAN WITH A WEAK, MARGINAL, BUSINESS.

WHAT HAPPENED AFTER

WITH THE "THREAT" PUT ON HOLD, NOW PRITZIK HAD A CHANCE TO MAKE A NEW 'LINE' AND A 'GOOD SEASON'

THE NEWS OF HIS SUCCESS BROUGHT A MERGER OFFER.

BUT THE CONTROLLING STOCK WAS IN THE HANDS OF GIPPLE ...

WHO WINDS UP IN CONTROL OF THE COMPANY

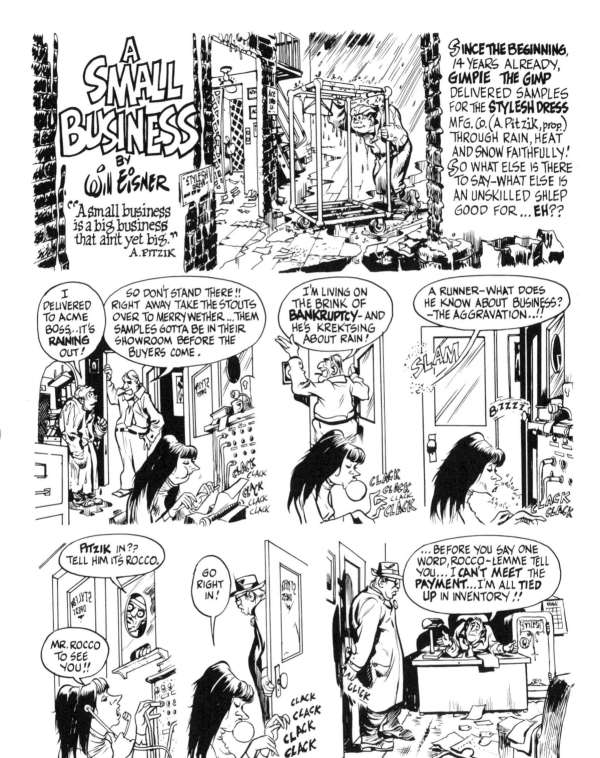

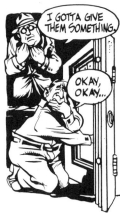

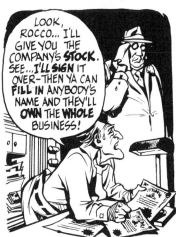

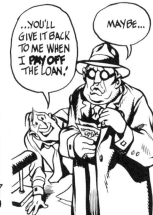

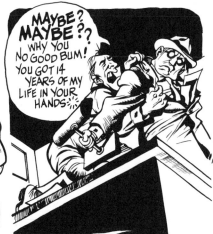

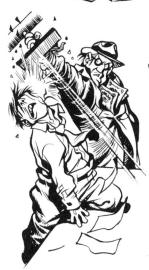

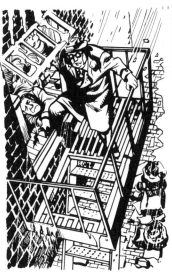

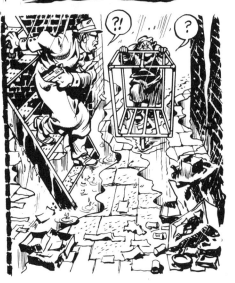

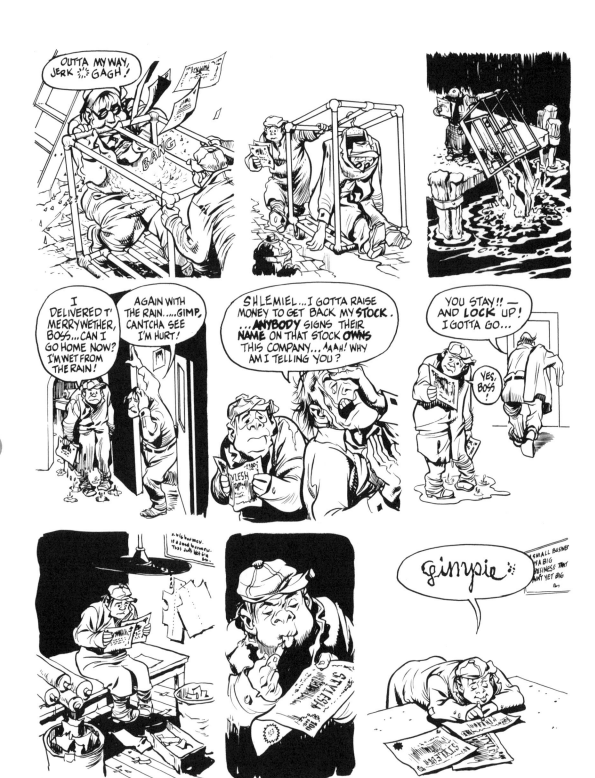

This story employs a single event in a single day to define a man and his life. The storyteller is always confronted with the difficulty of selecting a revealing incident that will withstand the reader's judgment of what is believable.

THE WINNER

IT'S A BEAUTIFUL MORNING... THE AIR IS COOL... A BIT CRISP AND DRY.... YESTERDAY'S RAIN LEFT A FEW PUDDLES HERE AND THERE BUT, HARDLY ANY PROBLEM TO VETERANS OF CITY STREET RUNNING.

THE COURSE WILL BE SOMEWHAT THE SAME AS LAST YEAR -- A FEW SMALL CHANGES -- BUT IN THE MAIN FAMILIAR TO ANYONE WHO KNOWS THIS CITY. THE ROUTE WILL TAKE THEM FROM MIDTOWN ACROSS THE EAST RIVER BRIDGE - INTO THE BOROUGHS, ALONG THE BELTWAY GOING NORTH TO THE CITY'S EDGE. THERE, IT WILL TURN AND COME BACK SOUTH THROUGH THE TENEMENTS -- DOWN THE MAIN AVENUE THAT BISECTS THE CITY... ALONG THE FINANCIAL DISTRICT, THEN THROUGH THE PARK AND ENDING HERE AT CENTRAL SQUARE FROM WHERE THEY STARTED... TWENTY EIGHT MILES OF CONCRETE POUNDING, FOLKS!!

SINCE DAWN, SPECTATORS HAVE BEEN STATIONING THEMSELVES ALONG THE ROUTE, HOPING FOR A GLIMPSE OF THE RUNNERS AS THEY GO BY. SUPPORTERS ARE GENERALLY SMALL GROUPS OR INDIVIDUALS HOPING TO SINGLE OUT A FRIEND IN THE HORDE OF STARTERS. THEY ARE AS UNREMARKABLE AS THE CONTESTANTS THEMSELVES, WHOSE PRIVATE REASONS FOR COMPETING IN THIS UNOFFICIAL MEET WITH ITS VAGUE REWARD REMAIN THE UNTOLD STORY OF THIS EVENT.

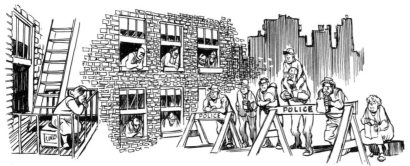

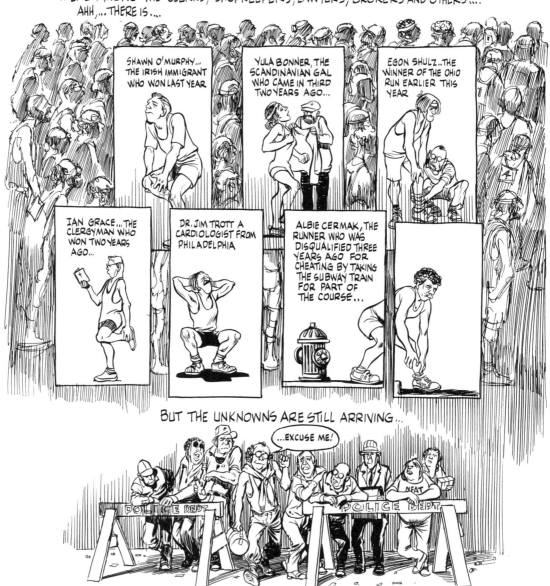

As the runners assemble, we can see a few familiar faces here and there among the clerks, shopkeepers, lawyers, brokers and others.... Ahh,...there is

Shawn O'Murphy... the Irish immigrant who won last year

Yula Bonner, the Scandinavian gal who came in third two years ago...

Egon Shulz...the winner of the Ohio run earlier this year

Ian Grace,...the clergyman who won two years ago...

Dr. Jim Trott a cardiologist from Philadelphia

Albie Cermak, the runner who was disqualified three years ago for cheating by taking the subway train for part of the course...

But the unknowns are still arriving...

...excuse me!

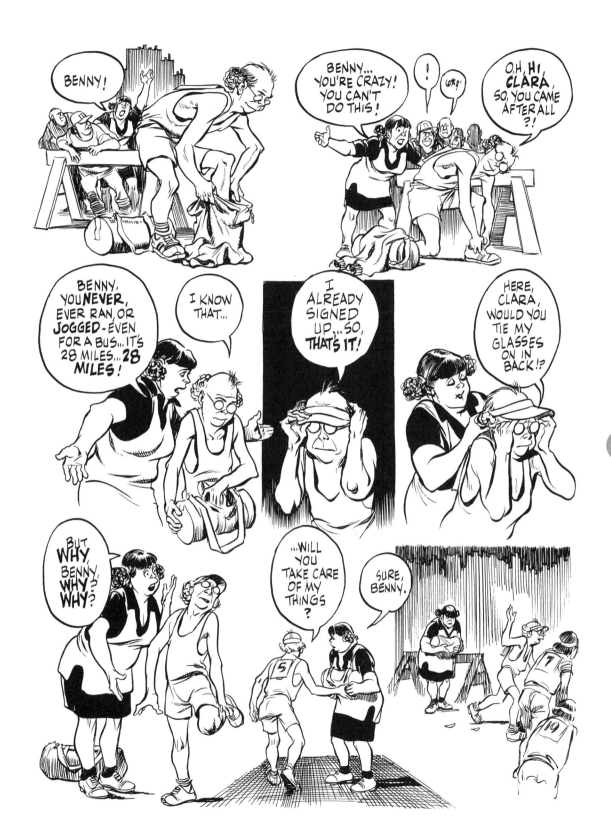

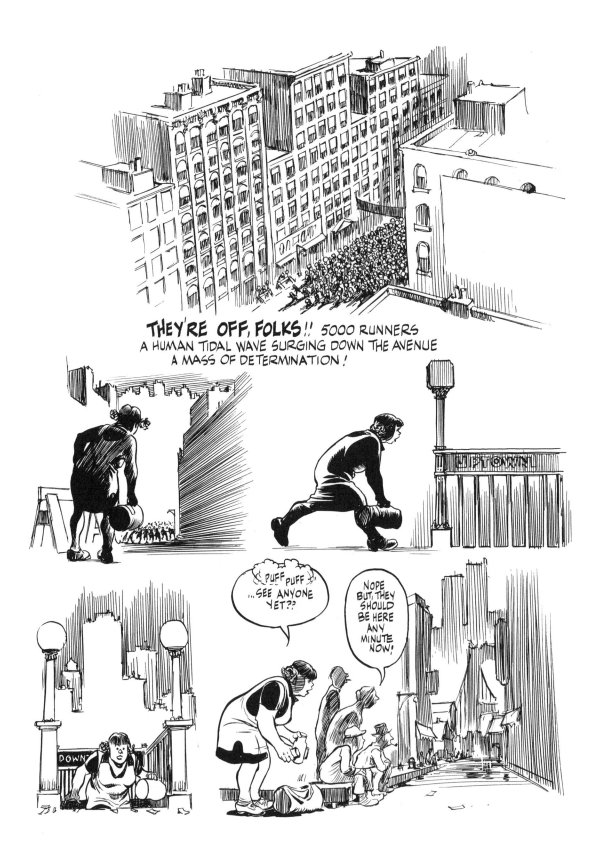

THEY'RE OFF, FOLKS!! 5000 RUNNERS
A HUMAN TIDAL WAVE SURGING DOWN THE AVENUE
A MASS OF DETERMINATION!

PUFF PUFF ...SEE ANYONE YET??

NOPE BUT, THEY SHOULD BE HERE ANY MINUTE NOW!

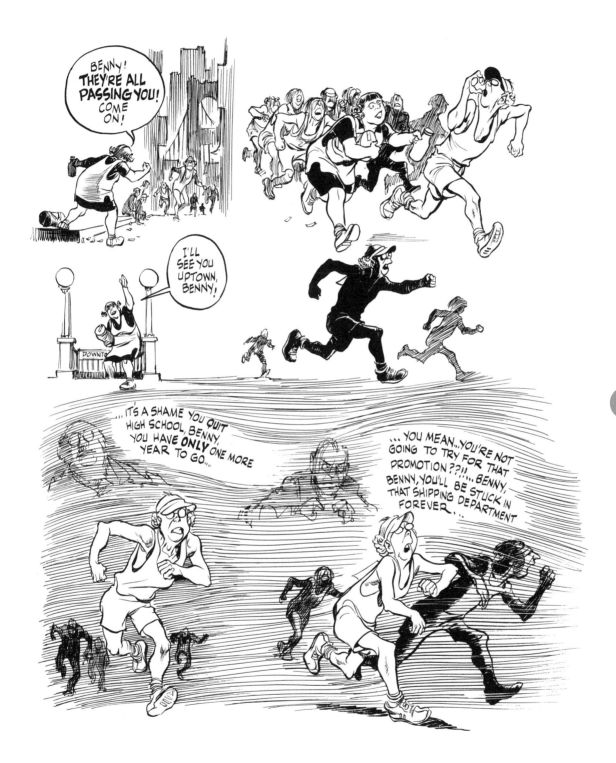

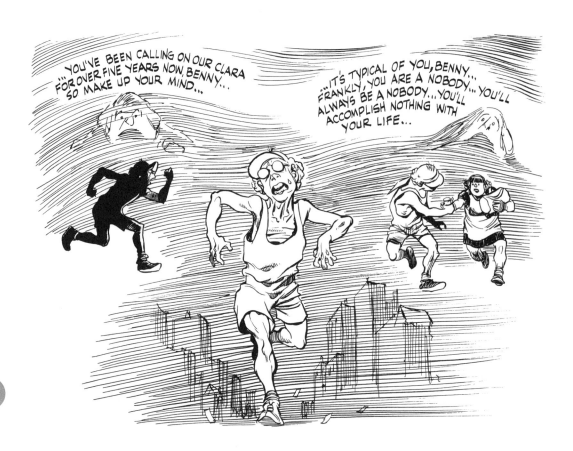

WELL, FOLKS,...THE 15TH CITY MARATHON HAS BECOME **HISTORY**...
THIS YEAR, THE WINNER IS TOR HUGEN WHO CAME ALL THE WAY FROM
EUROPE TO FINISH WELL AHEAD OF THE FIELD.....
....AS NIGHT FALLS, A QUIET SETTLES ON THE EMPTIED STREETS...
IT'S ALL OVER, FOLKS... GOOD NIGHT !

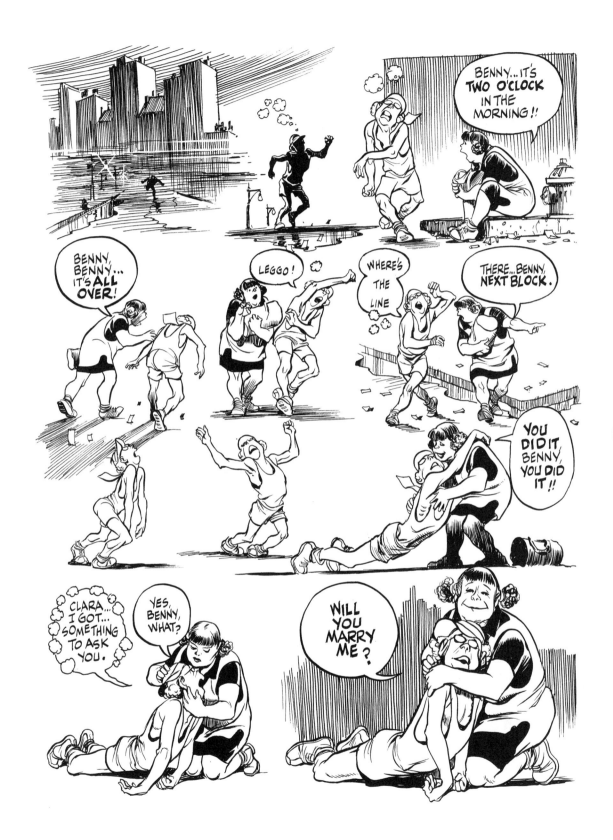

"POWERHOUSE LAYOUTS OR EXCESSIVE RENDERING TECHNIQUE, WHICH CAN OVERWHELM AND DISTRACT THE READER AND DOMINATE THE STORY, ARE COUNTER-PRODUCTIVE IN THIS FORM."

GABRIELLE BELL'S COLLECTION OF DIARY COMICS, *LUCKY*, IS A PERCEPTIVE GLIMPSE INTO a young woman's life. The unadorned drawing style, a simple scrawl, make her coimics look as if they could have been drawn on the day of the events described, and easily captures the ebb and flow of her life. The art is deceptive; it looks refreshingly unlabored yet clearly there is a careful attention to detail, form and proportion. The simplicity and directness of the drawing creates an easy intimacy with the reader that would be jeopardized by a more bombastic or illustrative style.

Monday, May 5th

In the morning before he went to work, I helped Tom move his stuff back to my place until the studio would be ready on the fifteenth.

As for me, I still haven't unpacked either. I don't know where to start, and don't care.

In the bathroom there is a sign:

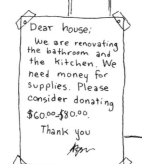

Dear house;
We are renovating the bathroom and the kitchen. We need money for supplies. Please consider donating $60.⁰⁰–$80.⁰⁰.
Thank you

On the refridgerater in the kitchen is a sign that says:

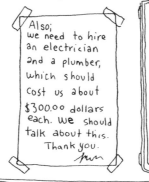

Also;
we need to hire an electrician and a plumber, which should cost us about $300.⁰⁰ dollars each. We should talk about this.
Thank you.

Now I am afraid to leave my room.

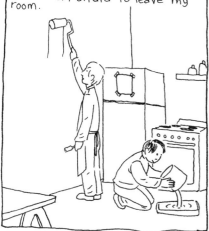

So I stay in here, with my spiritual and artistic pursuits.

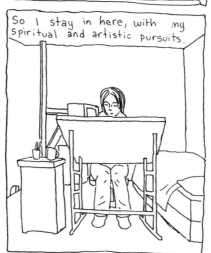

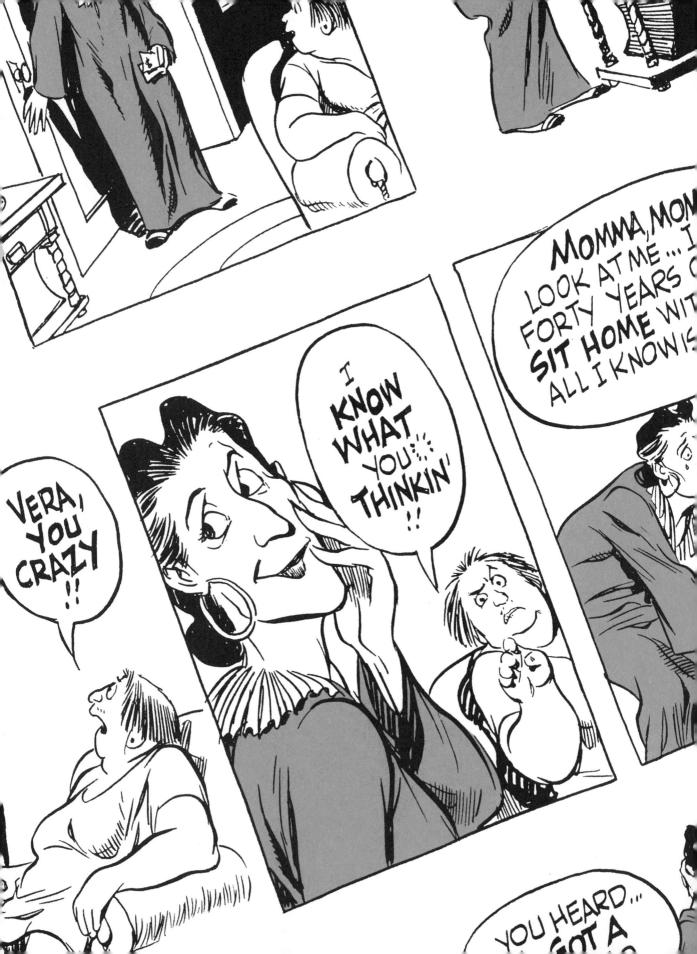

CHAPTER 6
THE READER

To whom are you telling your story?

The answer to this question precedes the telling because it is a fundamental concern of delivery. The reader's profile—his experience and cultural characteristics—must be reckoned with before the storyteller can successfully narrate the tale. Successful communication depends on the storyteller's own memory of experience and visual vocabulary.

EMPATHY

Perhaps the most basic of human characteristics is empathy. This trait can be used as a major conduit in the delivery of a story. Its exploitation can be counted upon as one of the storyteller's tools.

Empathy is a visceral reaction of one human being to the plight of another. The ability to "feel" the pain, fear or joy of someone else enables the storyteller to evoke an emotional contact with the reader. We see ample evidence of this in movie theaters where people weep over the grief of an actor, who is pretending while in an event that is not really happening.

Wincing with vicarious pain when observing someone being hit is, according to some scientists, evidence of fraternal behavior, the work of a neuropsychological mechanism developed in hominids from very early on. On the other hand, researchers argue that empathy results from our ability to run through our minds a narrative of the sequence of a particular event. This not only suggests a cognitive capacity but an innate ability to understand a story.

There is a whole body of clinical studies to support the conclusion that humans learn from infancy to watch and learn to interpret gestures, postures, imagery and other non-verbal social signals. From these, they can deduce meanings and motives like love, pain, and anger, among others.

The relevance of all this to graphic storytelling becomes even more apparent with the claims by scientists that the evolution of hominids' ability to read the intentions of others in their group involves their visual-neural equipment. This was possible, they contend, because as the visual system evolved it became more connected to the emotional centers of the brain. It helps, therefore, for an image maker to understand that all human muscles, in one way or another, are controlled by the brain.

Based on the understanding of empathy's cause and effect, we can then come to the fashioning of a reader-storyteller contract.

THE "CONTRACT" WITH THE READER

At the outset of the telling of a story, whether oral, written or graphic, there is an understanding between the storyteller and the listener, or reader. The storyteller expects that the audience will comprehend, while the audience expects the author will deliver something that is comprehensible. In this agreement, the burden is on the storyteller. This is a basic rule of communication.

In comics the reader is expected to understand things like implied time, space, motion, sound and emotions. In order to do this, a reader must not only draw on visceral reactions but make use of an accumulation of experience as well as reasoning.

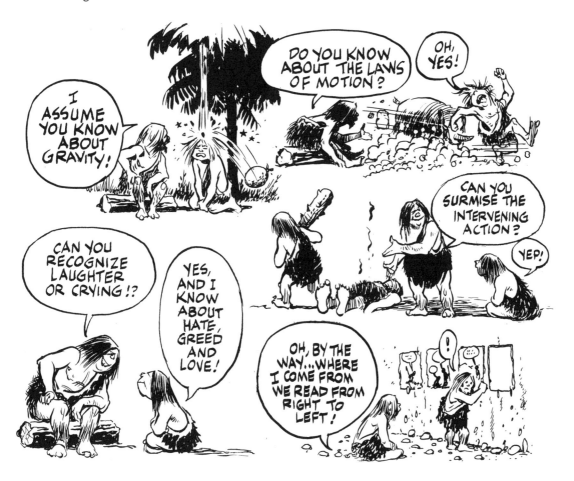

CONTROL OF THE READER

A major element in the reader-storyteller contract is the struggle to maintain reader interest. The devices used in the telling bind the reader to the storytelling.

For the storyteller this is a matter of control. Once the reader's attention is seized it cannot be allowed to escape.

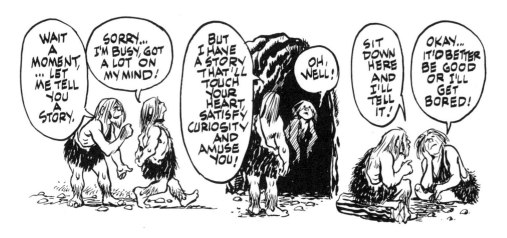

The key to reader control is relevance to his interest and understanding. There are a few fundamental themes (of which there are hundreds of permutations) which can be called universal. These include stories that satisfy curiosity about little known areas of life; stories that provide a view of human behavior under various conditions; stories that depict fantasies; stories that surprise; and stories that amuse.

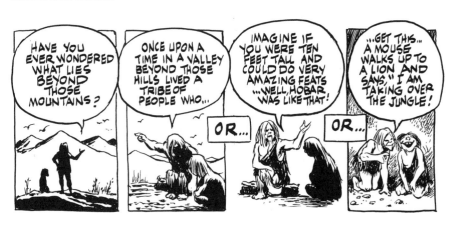

In comics, reader control is attained in two stages—attention and retention. Attention is accomplished by provocative and attractive imagery. Retention is achieved by the logical and intelligible arrangement of the images.

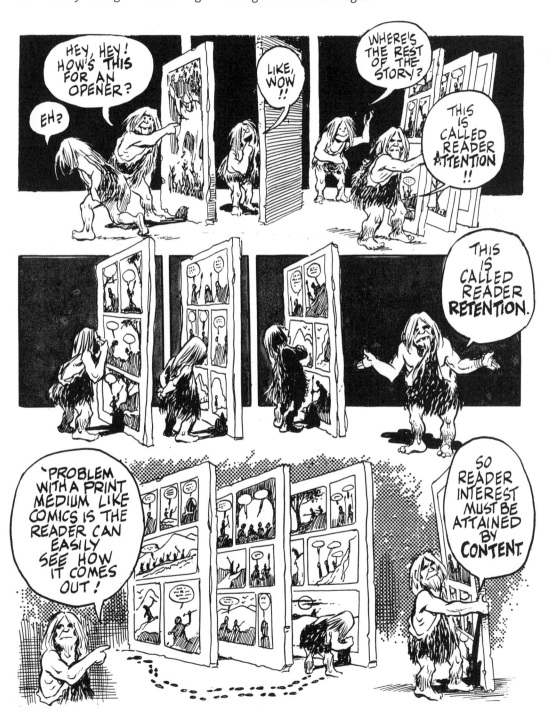

SURPRISE, SHOCK AND READER RETENTION

Surprise is an often used element in all storytelling. In the graphic language, the use of surprise requires stagecraft. In film it is achieved by a sudden and unexpected happening or appearance, usually unforeseen. This is reasonably easy to do because the audience is a spectator that can see only the events shown exactly in the order in which they are displayed. For example, sudden appearance is a commonly used device to achieve surprise or shock.

In comics, because the reader is in control of the acquisition, it is more difficult to surprise, shock or retain his interest. Sometimes a comics storyteller may try to use the turning of a page to achieve a surprise. But unless the reader is disciplined (does not skip ahead), he can elude the storyteller's grasp and "see what happens next." Aside from unexpected turns in the thread of a story, surprising the reader on a visual level remains a major problem.

In comics, the solution is to *surprise the character* with whom the reader is involved.

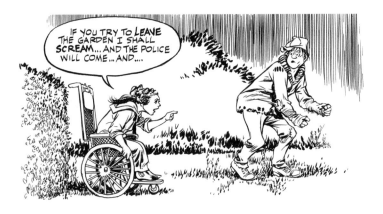

An example of an attempt to surprise the reader is demonstrated in the following sequence. The reader is led to expect a normal exchange between two unimpaired people over several pages. Of course, there is still the possibility that by "flipping" ahead, the surprise will be mitigated. So no attempt is made to surprise the reader with a "shock" graphic. It is left to the characters to act it out.

In this case, we have two surprises. One, we present a seemingly active, even athletic, man and reveal only later his infirmity (speechlessness). Two, we reveal the girl as crippled only after allowing her to react to his speechlessness in the manner of a "normal" person.

While the contrivance is choreographed, the reader is involved by the reaction of the characters. Without those reactions, the surprise would fail.

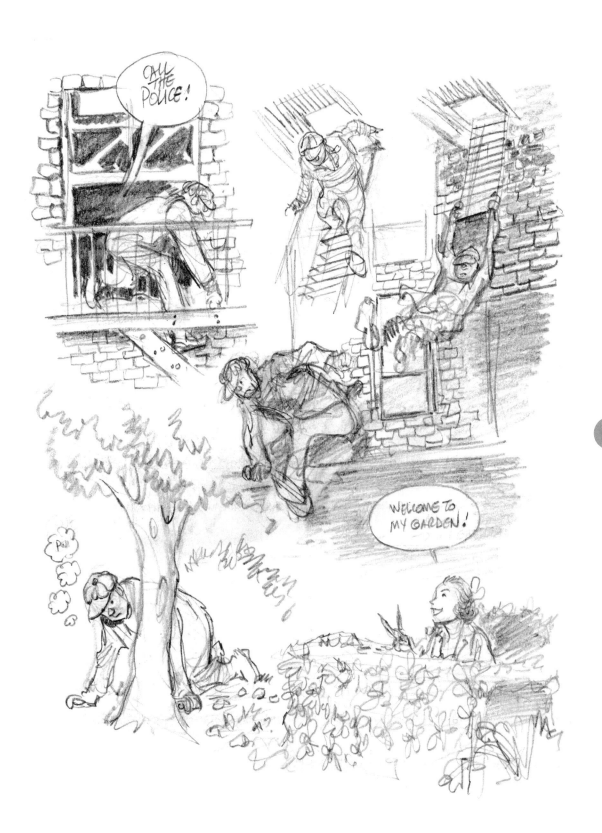

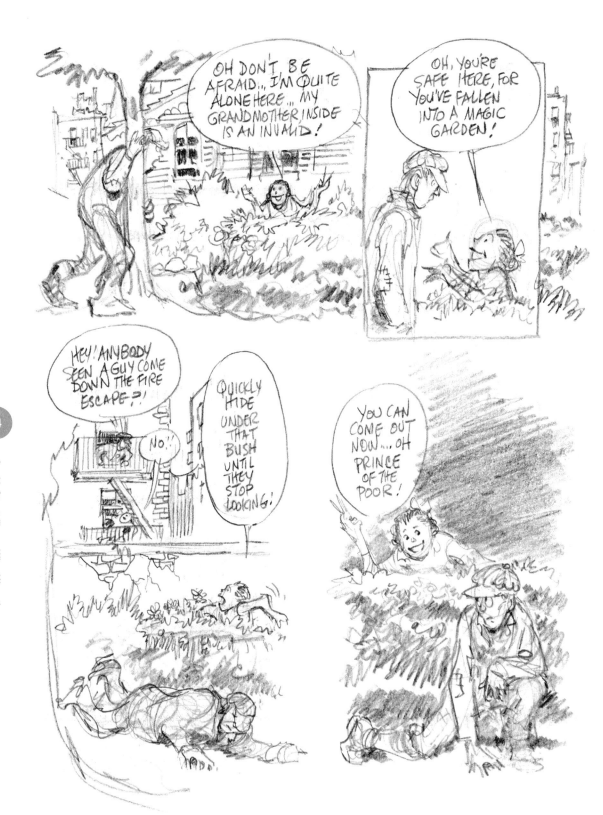

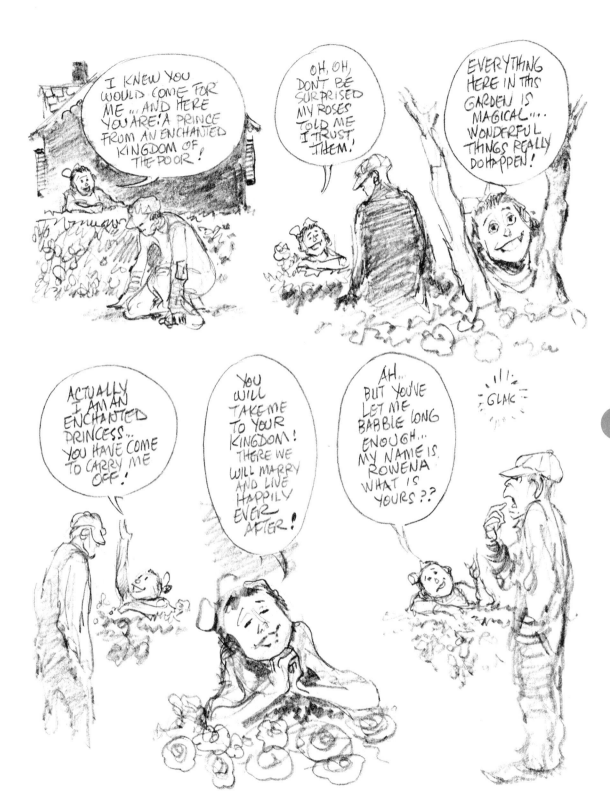

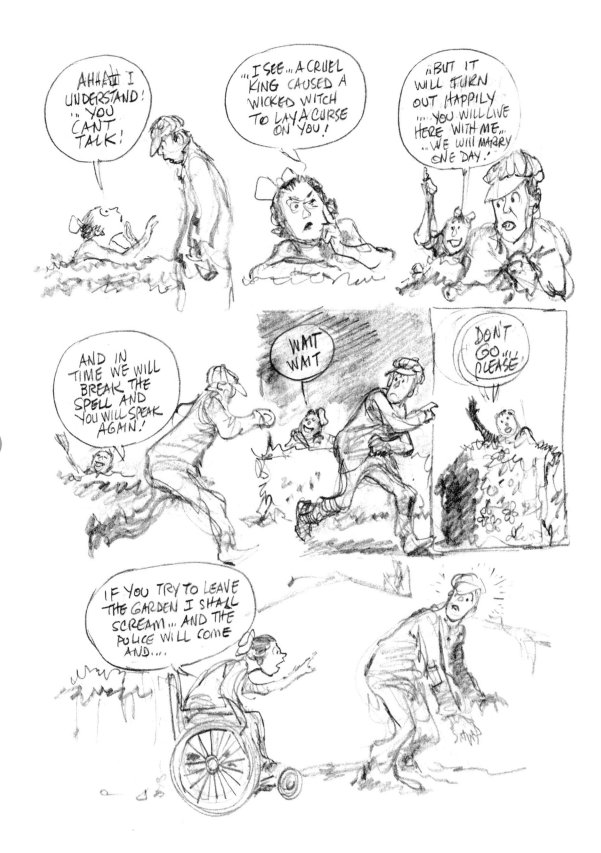

DIALOGUE: THE READER AS ACTOR

The comics medium does not have sound, music or motion, so this requires readers to participate in the acting out of the story. The dialogue, therefore, becomes a critical element. Where dialogue is not furnished, it requires that the storyteller depend on the reader's life experience to supply the speech that amplifies the intercourse between the actors.

In depicting a silent sequence of interaction, the comics storyteller must be sure to employ gestures and postures easily identifiable with the dialogue being played out in a reader's mind.

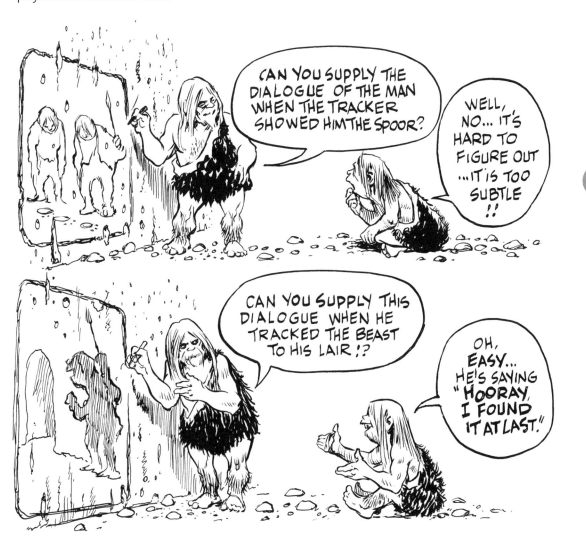

READER VS. DIALOGUE

In this sequence, the reader is forced to participate by supplying unspoken dialogue. In this case, the last panel supplies all the words needed. Used often in films, this device has the effect of compressing a sequence which might otherwise lose rhythm and credulity. In cases like this, the reader with some life experience can supply the dialogue.

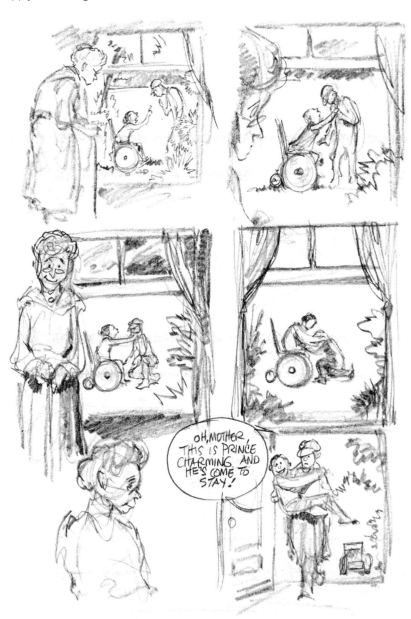

DIALOGUE VS. IMAGE

In reality, action precedes words. In comics, therefore, the dialogue is actually conceived after the action is devised.

In comics, no one really knows for certain whether the words are read before or after viewing the picture. We have no real evidence that they are read simultaneously. There is a different cognitive process between reading words and pictures. But in any event, the image and the dialogue give meaning to each other—a vital element in graphic storytelling.

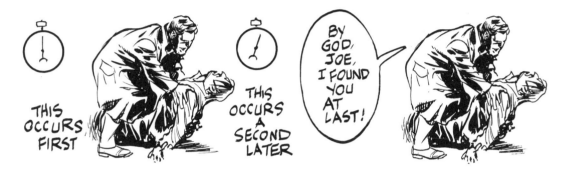

DIALOGUE VS. ACTION

Because a flow of action immediately takes on a rhythm, the dialogue must accommodate the pageantry. Balloons can impede flow by making unreasonable demands on the reader's sense of reality—and the storyteller's credibility.

There is a demand on the reader to maintain a sense of time. When there is an exchange of dialogue, time passes. Here is an exchange timed in seconds.

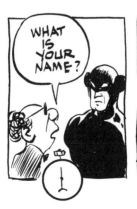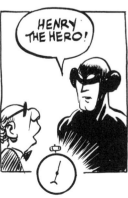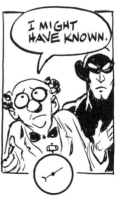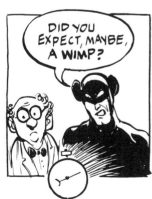

There is an almost geometric relationship between the duration of dialogue and the endurance of the posture from which it emanates. In this exchange, there is a perceived time lapse between the dialogue and the action. An actor gets into position and speaks his line. The other actor assumes a posture before responding. All this takes place in a matter of seconds.

Here is what happens when the comics storyteller allows an exchange of dialogue to emanate from the same image. There is a saving of space but it is at the expense of credibility.

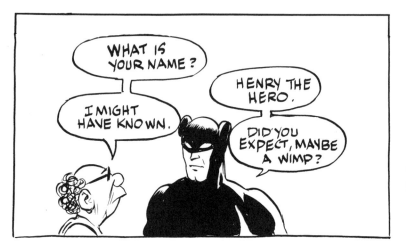

TIME ELAPSE BASED ON THE ENDURANCE OF THE DIALOGUE EXCHANGE

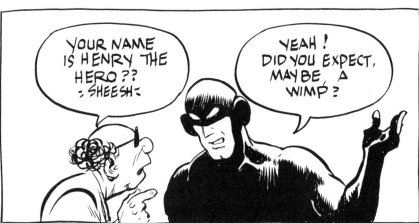

A MORE ECONOMICAL SOLUTION THAT PRESERVES THE BOND BETWEEN DIALOGUE AND ACTION.

If there is an applicable formula, it would be to ordain that the dialogue terminates the endurance of the image. The logic of this is that a protracted exchange of dialogue cannot be realistically supported by unmoving static images.

LETTERING DIALOGUE

Given the absence of sound, the dialogue in balloons acts as a script to guide the reader in reciting it mentally. The style of lettering and the emulation of accents are the clues enabling the reader to read it with the emotional nuances the comics storyteller intended. This is essential to the credibility of the imagery. There are commonly accepted lettering characteristics which imply sound level and emotion. To a certain extent, these are intuitive; below, the larger, bolder text implies greater volume.

STORY MOMENTUM

When the reader becomes involved with a story and is familiar with the rhythm and action, then his own contribution to the dialogue can be expected. The story's momentum enables the comics storyteller to employ wordless passages successfully.

In the following sequence, much dialogue is suspended (in order to accelerate the narrative) and the reader is expected to supply it.

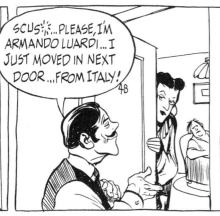

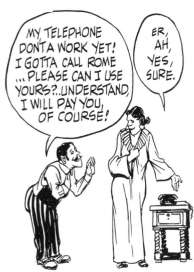

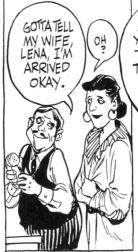

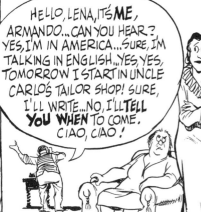

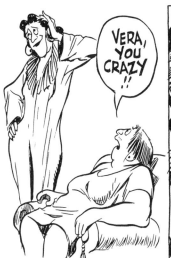

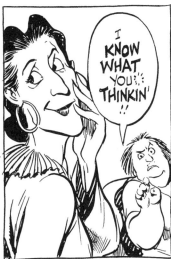

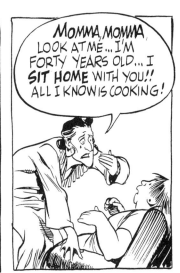

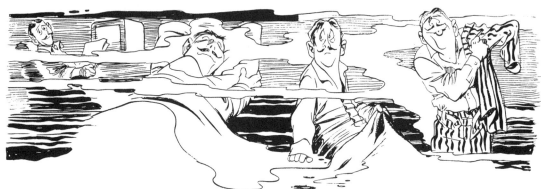

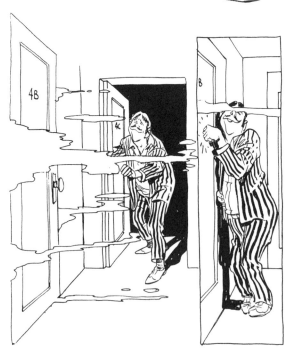

WELL ·AHEM· WHAT ·ER· SURPRISE, MR. LUARDI ...YOU ARE JUST IN TIME FOR SUPPER!

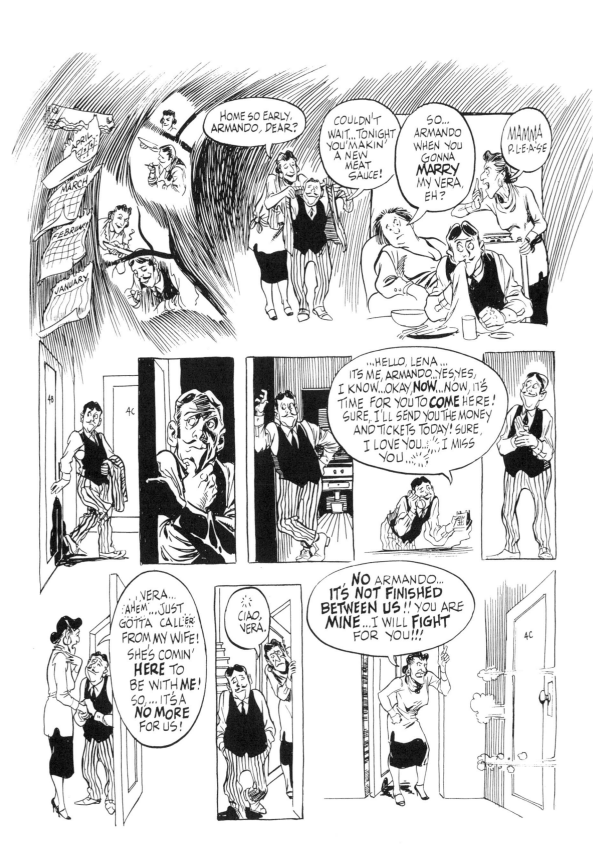

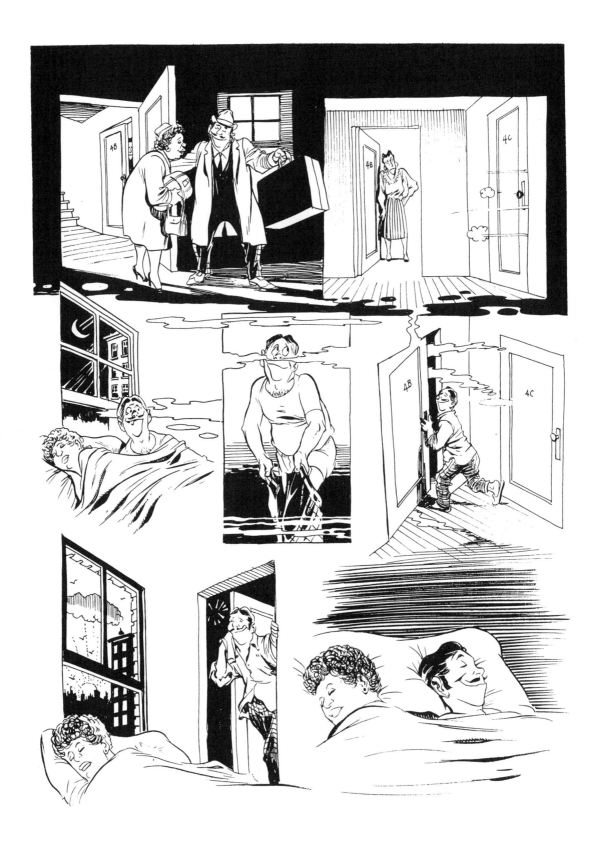

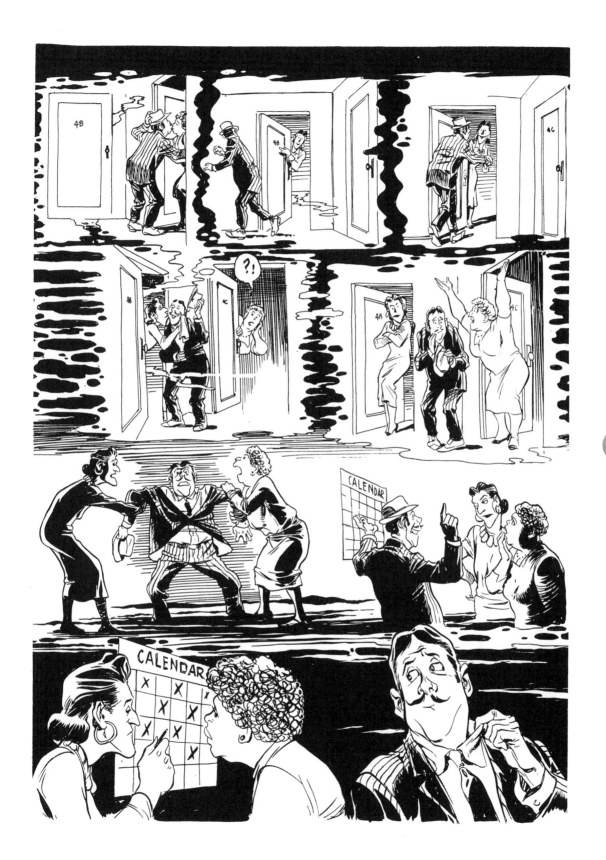

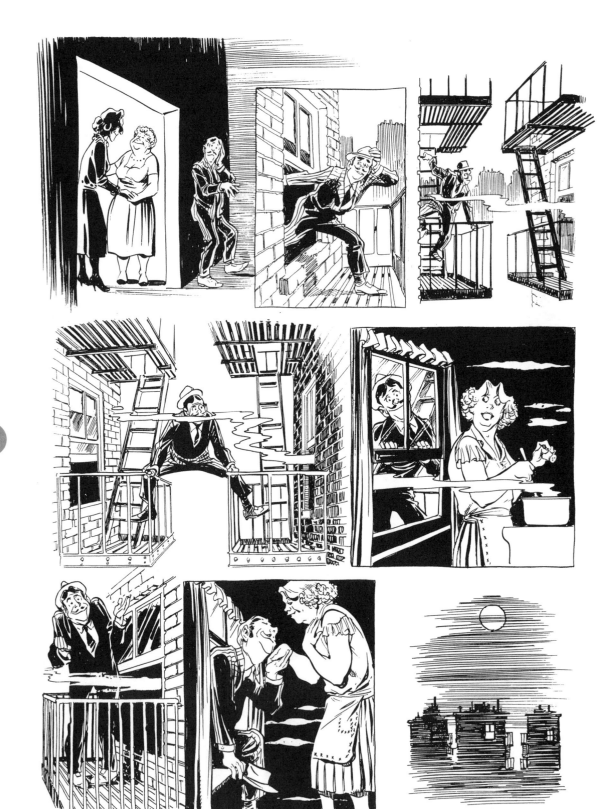

CHAPTER 7

READER INFLUENCES

No storyteller should ignore the fact that the reader has other reading experiences. Readers are exposed to other mediums, each of which has its own rhythm. There is no way of measuring it, but we know that these different media influence each other.

FILM
THE AUDIENCE IS CARRIED THROUGH THE TELLING. IT PROVIDES NO TIME FOR SAVORING PASSAGES OR CONTEMPLATION. THE VIEWER IS A SPECTATOR OF ARTIFICIAL REALITY.

INTERACTIVE VIDEO
ELECTRONICALLY STORED TEXT AND IMAGERY LETS VIEWER MANIPULATE THE RHYTHM OF DISPLAY AND ACQUISITION. THERE IS NO TACTILE SENSE AS PROVIDED IN PRINT.

TEXT
ACQUISITION REQUIRES LITERACY, WHICH INVOLVES THOUGHT, PARTICIPATION AND RECALL...READERS CONVERT WORDS INTO IMAGERY.

COMICS
ACQUISITION IS LESS DEMANDING THAN TEXT BECAUSE IMAGERY IS PROVIDED. THE QUALITY OF THE TELLING HINGES ON THE ARRANGEMENT OF TEXT AND IMAGE. THE READER IS EXPECTED TO PARTICIPATE.

POW!
HELP
POW
!* BANG

READING THE IMAGERY REQUIRES EXPERIENCE AND ALLOWS ACQUISITION AT THE VIEWER'S PACE. THE READER MUST INTERNALLY PROVIDE SOUND AND ACTION IN SUPPORT OF THE IMAGES.

READING RHYTHM

Broadly speaking, and setting aside individual cognitive skills, a reader's rate of acquisition can be best described as a reading rhythm. While readers may adjust their expectations to the discipline and conventions of comics, there is a reflexive referral to other media just as there is to a memory of a real experience.

Comics readers will tolerate the emulation of another medium's rhythm of narration, but in printed comics the comics storyteller must deal with the fact that the medium is still delivered on paper. This brings into play physical factors—i.e., paper does not require machinery for transmission. The reader is in total control of the acquisition, free of any manipulation by either the machine or the rhythm of its output.

Webcomics (a term for comics displayed on the Internet) provide the storyteller with more flexibility in the control of the reader, but so far comics storytellers have largely retained print rhythms when working digitally.

FILM RHYTHM IN PRINT This emulates film rhythm as its camera "pans" or sweeps from image to image.

PRINT RHYTHM IN PRINT In print, the rhythm of reading requires images that truly connect in order to more clearly evoke the intervening action.

While there seems to be an overt relationship between comics and film, there is a substantial and underlying difference.

Both deal in words and images. Film buttresses these with sound and the illusion of real motion. Comics must allude to all of this from a platform of static panels. Film employs photography and a sophisticated technology to transmit realistic images. Again, comics is limited to print. Film purports to provide a real experience, while comics narrates it. These singularities, of course, affect the approaches of the filmmaker and the cartoonist.

Both are storytellers working through their mediums to make contact with an audience. But each has a different engagement with its audience. Film requires nothing more than spectator attention, while comics needs a certain amount of literacy and participation. A film watcher is imprisoned until the film ends while the comics reader is free to roam, to peek at the ending, or dwell on an image and fantasize.

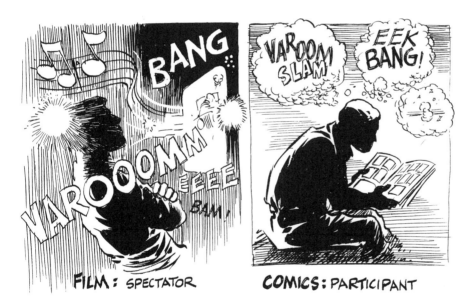

FILM: SPECTATOR COMICS: PARTICIPANT

But here is where the paths really diverge. Film proceeds without any concern about the literary skills or reading ability of its audience, whereas the comic must deal with both of these. Unless comics readers can recognize the imagery or supply the necessary events that the arrangement of images imply, no communication is achieved. The comics maker is obliged, therefore, to devise images that connect with the reader's imagination.

The comics maker working in modern times must deal with a reader whose life experience includes a substantial amount of exposure to film.

Because film experience (despite the fact that it is contrived) tends to be retained, the comics narrator must deal with this experience as if it were real. It is therefore inescapable that the elements of storytelling—rhythm, problem resolution, cause and effect, as well as the more cognitive elements—relate to the reader's experience as a whole. There is an opportunity for reader contact here.

One cannot ignore the fact that the television "experience" can be aborted with the touch of a button. The influence of this on attention span and retention cannot be dismissed.

In comics, it is tempting to co-opt film clichés that the cinema reader accepts viscerally. Film often uses the viewer's eye as the camera. In this device, the actors remain in position while the camera moves in and around their faces or bodies. Another cliché is the presentation of what an actor sees after he is shown seeing something. Comics makers frequently are unsuccessful in emulating this because they underestimate the amount of space this requires in print.

In film, sound and dialogue do not occupy visual space, they are heard at another level. Imitating film in a comics sequence can make the sequence hard to read, as the following shows.

FILM SEQUENCE

COMICS SEQUENCE When a comic emulates film camera technique, it can lose readability. The same event can be told more frugally, leaving room for the rest of the story.

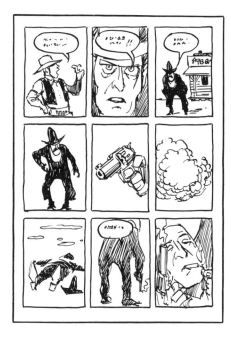 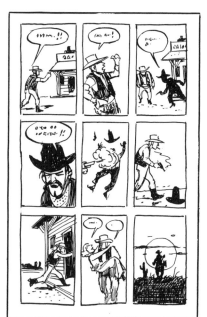

HOW COMICS INFLUENCE FILM

Film makers frequently find adaptable ideas in comics. The comics storyteller is not working with real time or motion, so he is not restricted in any way by the reality of his images. The comics storyteller is free to invent and distort reality by using caricatures and devised machinery which, in reality, could not possibly work. The use of costumed heroes, acceptable in comics, was the result of the innovative freedom comics storytellers enjoyed because they were unfettered by the confines of the realism in live theater or film.

NATIONAL INFLUENCES

Historically, American films, with their broad international distribution, helped establish global visual and story clichés. Comics benefited and rode on their acceptance.

After World War II, each country began to develop its own cadre of comic book talent. Comic books were soon published in individual countries for indigenous populations. French, Italian, Spanish, German, Mexican, Scandinavian, Japanese and a host of other artists and writers create comics to satisfy their own readers with stories, art and icons that reflect their own national culture. This has an influence on storytelling in comics; certain stereotypical images retain a national character.

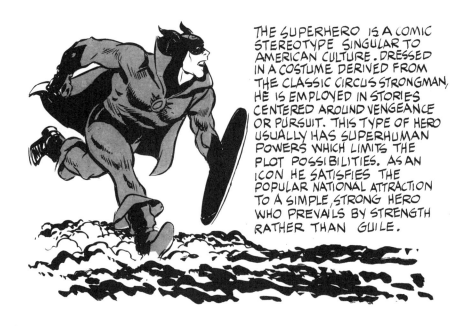

THE SUPERHERO IS A COMIC STEREOTYPE SINGULAR TO AMERICAN CULTURE. DRESSED IN A COSTUME DERIVED FROM THE CLASSIC CIRCUS STRONGMAN, HE IS EMPLOYED IN STORIES CENTERED AROUND VENGEANCE OR PURSUIT. THIS TYPE OF HERO USUALLY HAS SUPERHUMAN POWERS WHICH LIMITS THE PLOT POSSIBILITIES. AS AN ICON HE SATISFIES THE POPULAR NATIONAL ATTRACTION TO A SIMPLE, STRONG HERO WHO PREVAILS BY STRENGTH RATHER THAN GUILE.

There is a strong national influence on any comics storyteller which makes it difficult to produce images with a deliberate international intent. However, the fact that many images portray universal human posture and gesture does serve to maintain the viability of the visual language.

CHAPTER 8

IDEAS

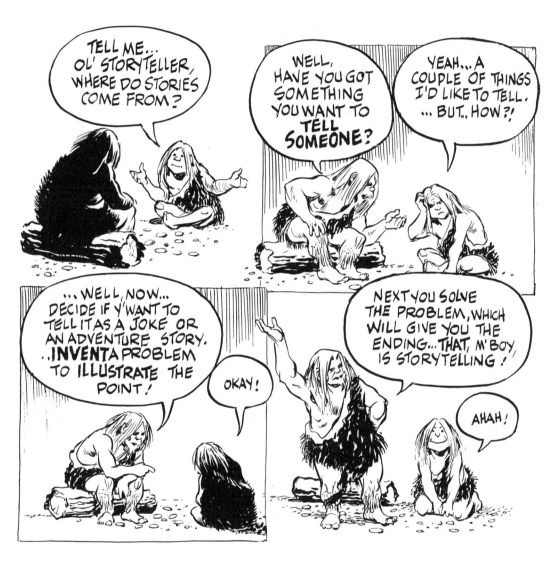

Most stories come from a premise. This is the basis of the contract with the reader. The following are some popular story premises: "What if...?" "Let me tell you about what happened to..." "Next, my hero is thrown into this adventure..." and "Have you heard the one about...?"

WHAT IF?

While a major element of storytelling draws on experience and reality, another source centers on the fabrication of a problem.

Here are three viable premises for a story. They touch on fundamental human concerns—fear and curiosity. In these the need to learn about how one might deal with a threat is satisfied by the manner in which the protagonist solves the problem.

WHAT IF... THE SEED YOU PLANTED IN YOUR BACKYARD BECAME A TREE-TYPE WEED THAT GREW SO FAST IT DOUBLED ITS HEIGHT UNTIL IT TOWERED OVER THE **ROOF** AND WOULD NOT STOP GROWING.

WHAT IF... YOU WOKE UP ONE MORNING TO FIND YOU HAD MUSCLES OF **STEEL** AND YOU COULD OUTRUN A SPEEDING TRAIN AND COULD EASILY LIFT YOUR CAR BY HAND.

WHAT IF... THE EARTH'S ORBIT WAS SUDDENLY **CHANGED** AND EXTRA-TERRESTRIAL ALIENS **FROM OTHER** PLANETS COULD NOW EASILY REACH EARTH.

For the comics storyteller, the "what if" formula provides a narrative with a "peg" upon which to hang a contrived sequence of events. It also offers the opportunity to fashion imagery that does not have to answer to a reality test.

The following is the opening chapter from *Signal from Space* (a.k.a. *Life on Another Planet*) published by Kitchen Sink Press in 1978.

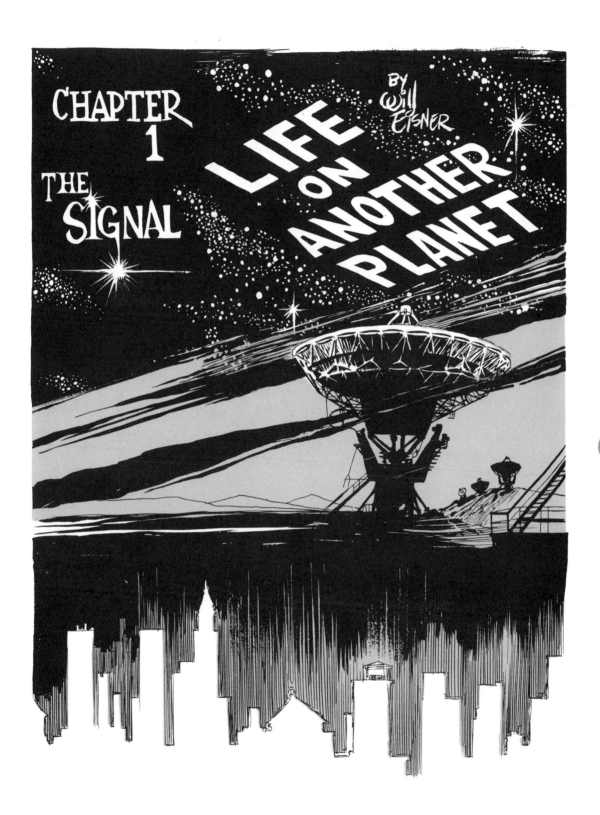

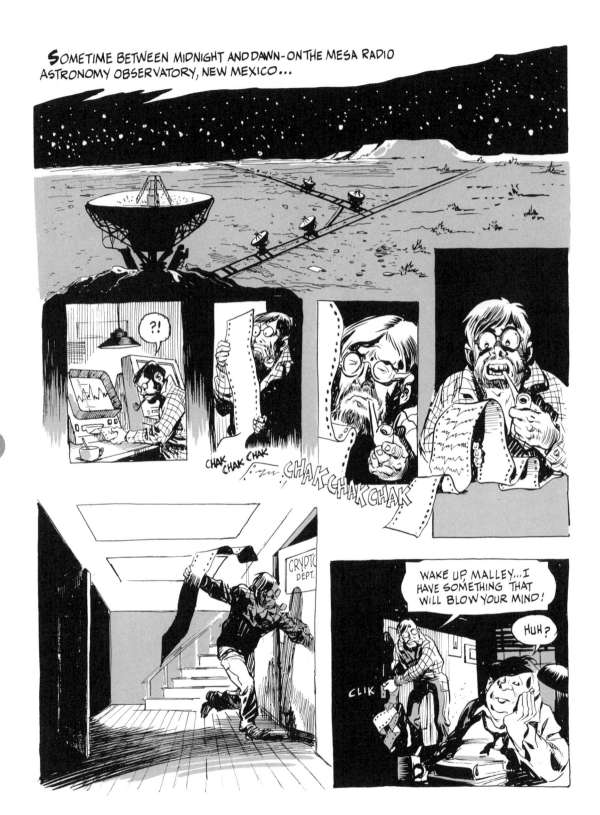

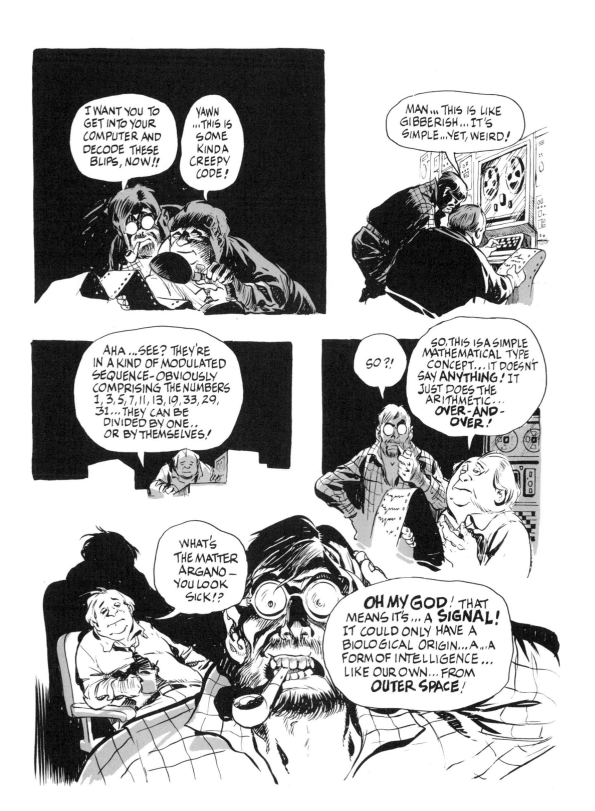

Ideas

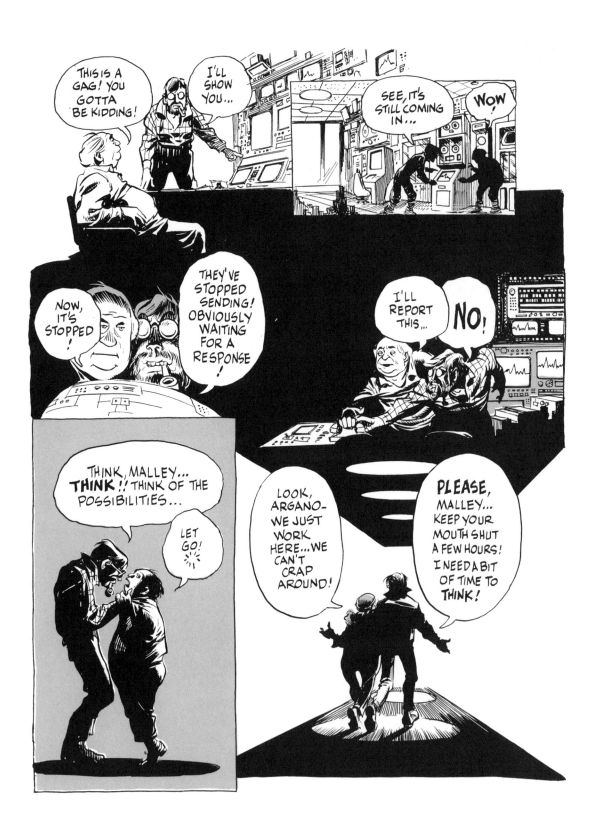

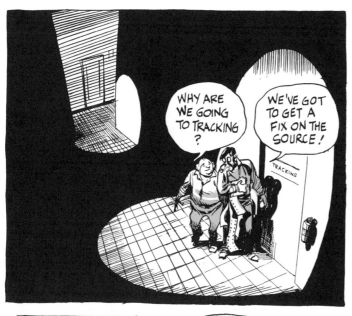

WHY ARE WE GOING TO TRACKING?

WE'VE GOT TO GET A FIX ON THE SOURCE!

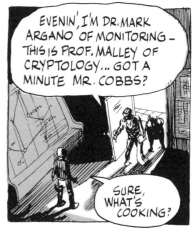

EVENIN', I'M DR. MARK ARGANO OF MONITORING — THIS IS PROF. MALLEY OF CRYPTOLOGY... GOT A MINUTE MR. COBBS?

SURE, WHAT'S COOKING?

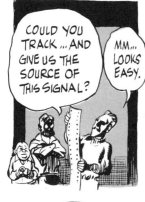

COULD YOU TRACK... AND GIVE US THE SOURCE OF THIS SIGNAL?

MM... LOOKS EASY.

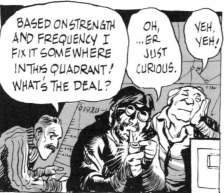

BASED ON STRENGTH AND FREQUENCY I FIX IT SOMEWHERE IN THIS QUADRANT! WHAT'S THE DEAL?

OH, ...ER JUST CURIOUS.

YEH, YEH!

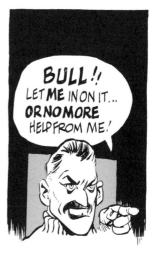

BULL!! LET ME IN ON IT... OR NO MORE HELP FROM ME!

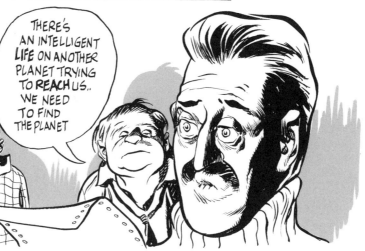

OKAY... OKAY... WE GOT A SIGNAL... DECODE SAYS ITS A KIND OF MESSAGE.

THERE'S AN INTELLIGENT LIFE ON ANOTHER PLANET TRYING TO REACH US.. WE NEED TO FIND THE PLANET

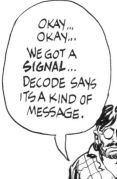

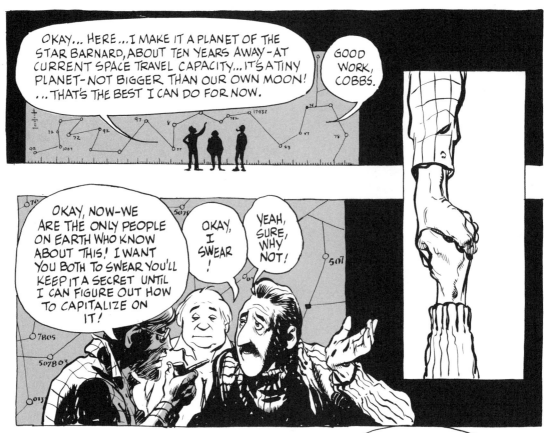

OKAY... HERE... I MAKE IT A PLANET OF THE STAR BARNARD, ABOUT TEN YEARS AWAY—AT CURRENT SPACE TRAVEL CAPACITY... IT'S A TINY PLANET—NOT BIGGER THAN OUR OWN MOON! ...THAT'S THE BEST I CAN DO FOR NOW.

GOOD WORK, COBBS.

OKAY, NOW—WE ARE THE ONLY PEOPLE ON EARTH WHO KNOW ABOUT THIS! I WANT YOU BOTH TO SWEAR YOU'LL KEEP IT A SECRET UNTIL I CAN FIGURE OUT HOW TO CAPITALIZE ON IT!

OKAY, I SWEAR!

YEAH, SURE, WHY NOT!

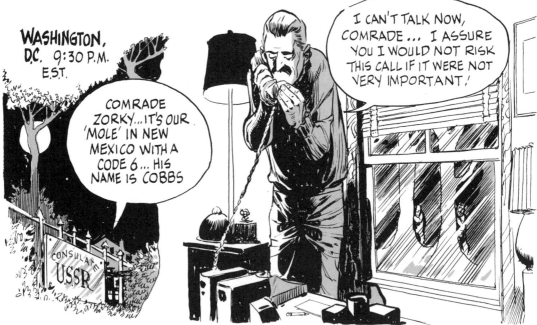

WASHINGTON, D.C. 9:30 P.M. E.S.T.

COMRADE ZORKY...IT'S OUR 'MOLE' IN NEW MEXICO WITH A CODE 6... HIS NAME IS COBBS

I CAN'T TALK NOW, COMRADE... I ASSURE YOU I WOULD NOT RISK THIS CALL IF IT WERE NOT VERY IMPORTANT!

CONSULATE U.S.S.R.

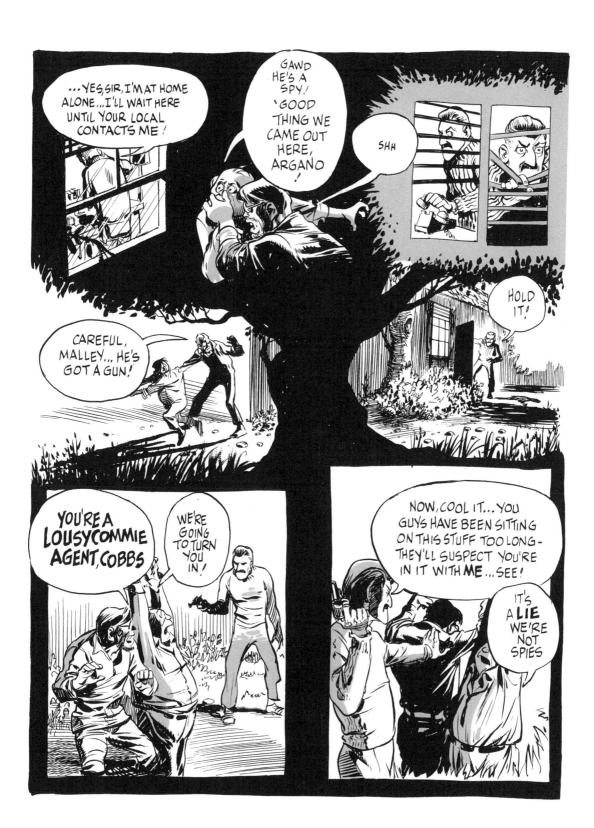

LOOK AT IT THIS WAY... THIS IS INFORMATION THAT BELONGS TO THE WORLD — NOT FOR SOME HUSTLER ... OR ONE LOUSY CAPITALIST NATION ... JUST THINK OF THE HISTORY OF MAN'S DEALINGS WITH NEW TERRITORIES... WE'RE BARBARIANS! NO, AT LEAST IF TWO MAJOR NATIONS SHARE IN IT THEY WILL HAVE SOME CHECK ON EACH OTHER!

...THIS IS A MORAL ISSUE! BESIDES — THAT SIGNAL WILL BE BEAMED AT EARTH AGAIN...THEN THE U.S. WILL HAVE IT TOO...SO, WHAT'S THE BIG DEAL?

LISTEN, ARGANO...THE KGB DOESN'T YET KNOW WHAT I HAVE ...SO, WHEN THEY GET HERE I'LL SHARE CREDIT WITH YOU. THEY'LL ARRANGE FOR YOU TO DEFECT TO THE U.S.S.R...YOU'LL BE A BIG SHOT THERE!

HOW ABOUT THAT?

IT STINKS, COBBS ...NO!

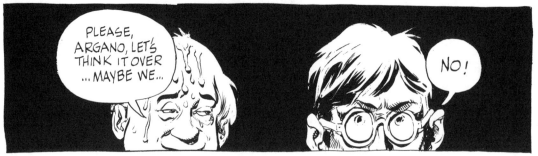

PLEASE, ARGANO, LET'S THINK IT OVER ...MAYBE WE...

NO!

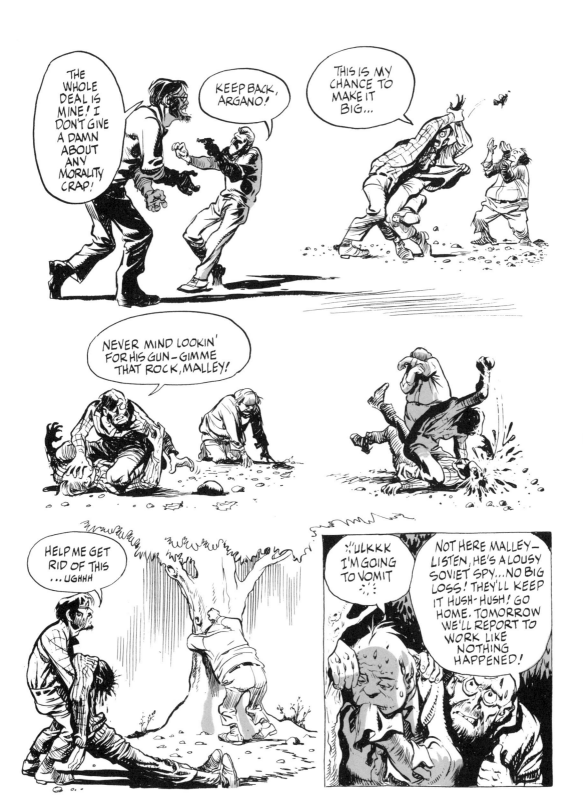

An audience is always interested in the experiences of someone with whom it can relate. There is something very private that occurs within the reader while he "shares" the actor's experience. The operative word is "share," because the inner feelings of the protagonist are understandable to the reader who would have similar emotions under the same circumstances.

In telling such a story in a graphic medium, it is necessary to establish credibility. In comics particularly, a prologue helps to invest the major character with some dimension. To do this, a prologue needs to be economical. A long prologue

IN TELLING SUCH A STORY IN A GRAPHIC MEDIUM, IT IS NECESSARY TO ESTABLISH CREDIBILITY. IN COMICS PARTICULARLY, A PROLOGUE HELPS TO INVEST THE MAJOR CHARACTER WITH SOME DIMENSION.

runs afoul of space limitations and a short one leaves the reader too much to contribute. Stories built around a protagonist often depend on a prologue to quickly introduce him.

In the following novella, "Sanctum," from *Invisible People,* a prologue occupies the first four pages.

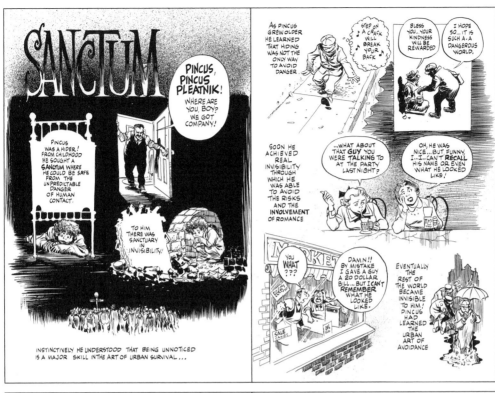

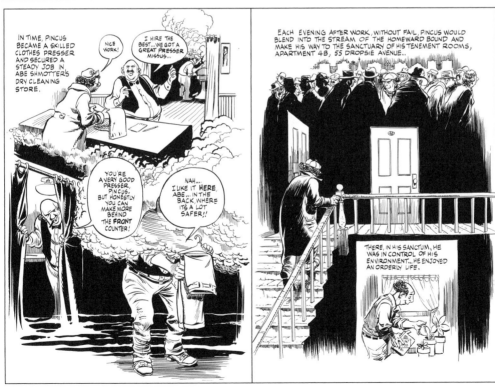

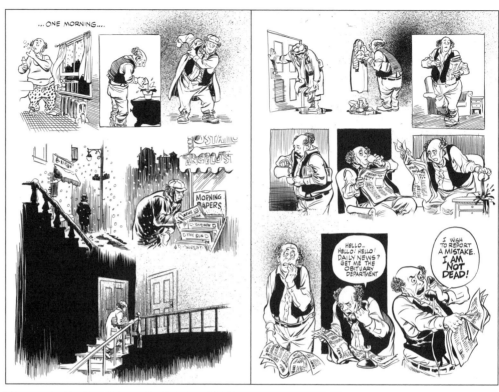

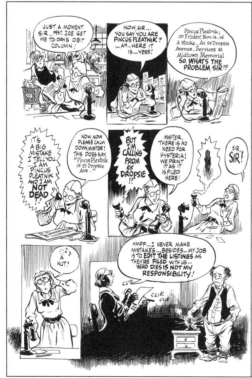

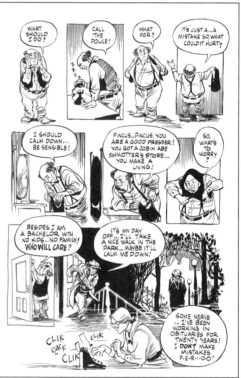

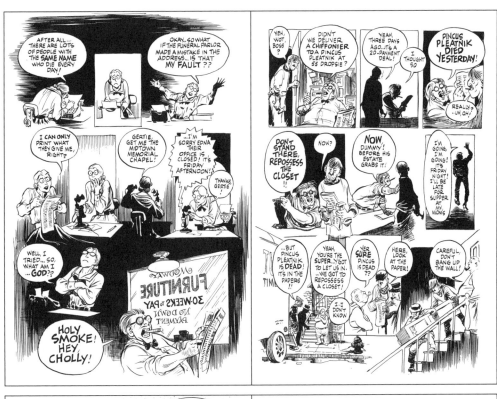

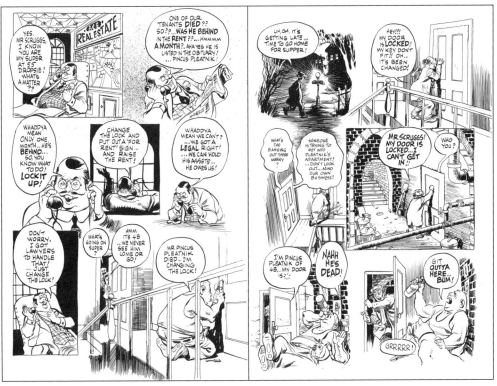

Ideas

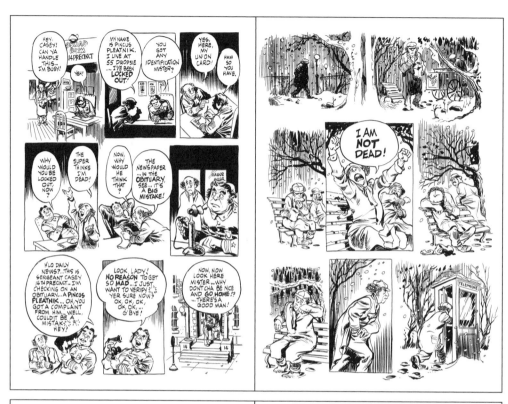

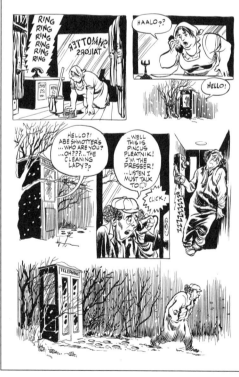

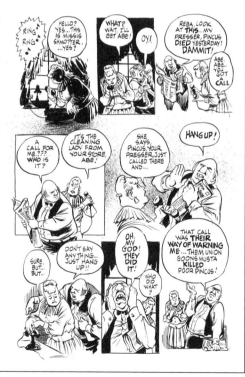

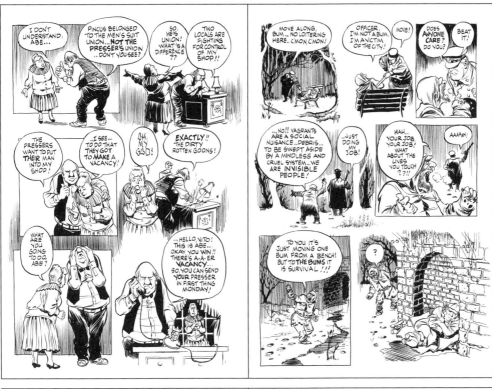

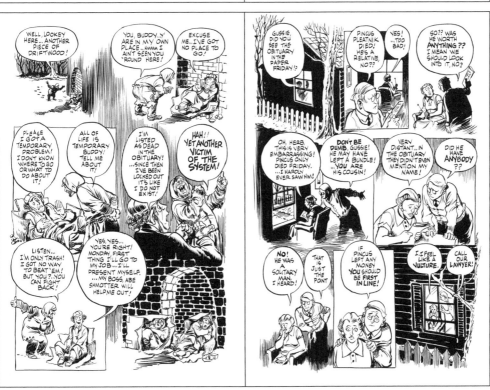

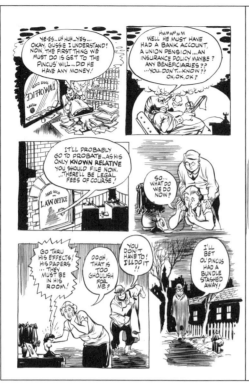

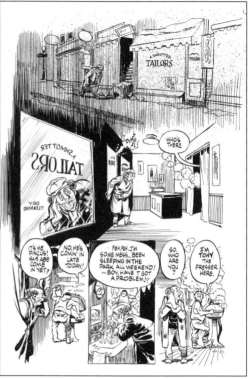

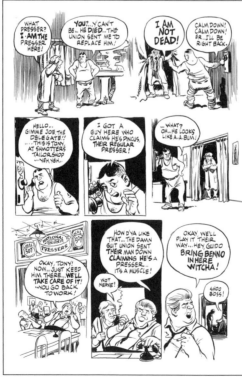

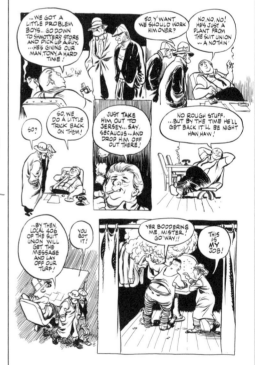

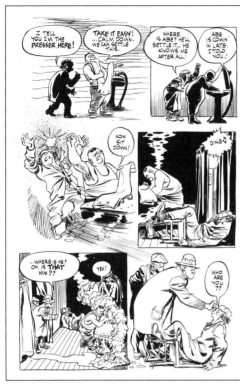

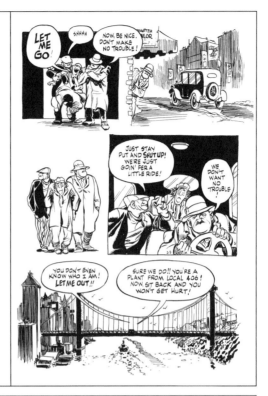

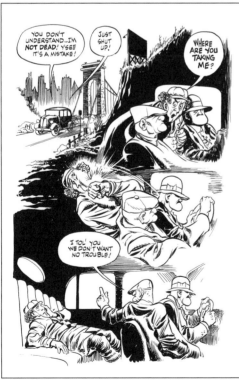

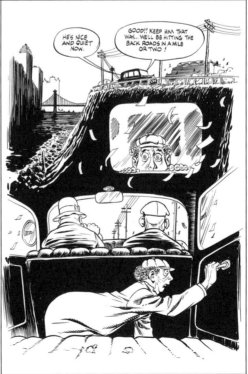

Ideas

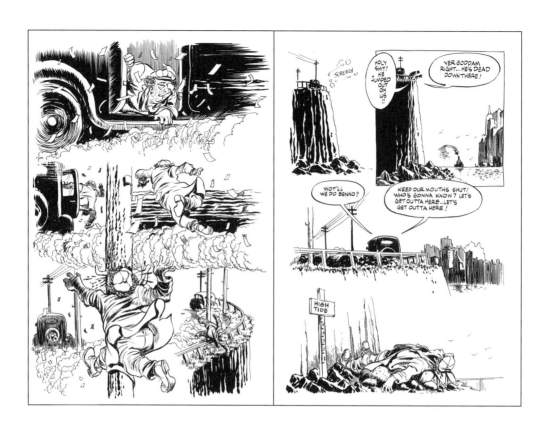

NEXT MY HERO IS THROWN INTO THE FOLLOWING ADVENTURE

In graphic storytelling, perhaps the most comfortable format is the one in which a continuing character with well-established characteristics is plunged into a challenging adventure.

Here the comics storyteller need only arrange a set of "trials" for the hero. In such a story, the reader does not expect a complex plot or a tightly woven fabric of circumstances. Indeed, the simpler the problem the better. *Action* is the plot.

Such a story situation is common to superhero stories. Action serves the storyteller well because superheroes are one-dimensional. Given the fact that this kind of hero's attributes are essentially physical—unlimited strength, vision, locomotion etc.—the threat can be in response to the nature of these characteristics. In this kind of story, the absence of subtlety in interaction makes for predictable plots. The comics storyteller can therefore resort to the novelty of movie-style graphics. The movie audience develops a kind of cinematic literacy over time and will, when reading comics, often anticipate the outcome of familiar situations. By employing the images in a special effects style with striking camera angles the storyteller can achieve excitement within a banal plot.

BY EMPLOYING THE IMAGES IN A SPECIAL EFFECTS STYLE WITH STRIKING CAMERA ANGLES THE STORYTELLER CAN ACHIEVE EXCITEMENT WITHIN A BANAL PLOT.

"MOVIE-SHOT" IMAGES HAVE A CERTAIN STORY VALUE IN PRINT BECAUSE THEY EVOKE MOOD AND A FEELING OF ENVIRONMENT.

In the following example, the hero is not superhuman. He is established as a powerful but vulnerable fighter. The adventure into which he is thrown capitalizes on his vulnerability. The tale centers around the hero's ability to prevail.

Ideas

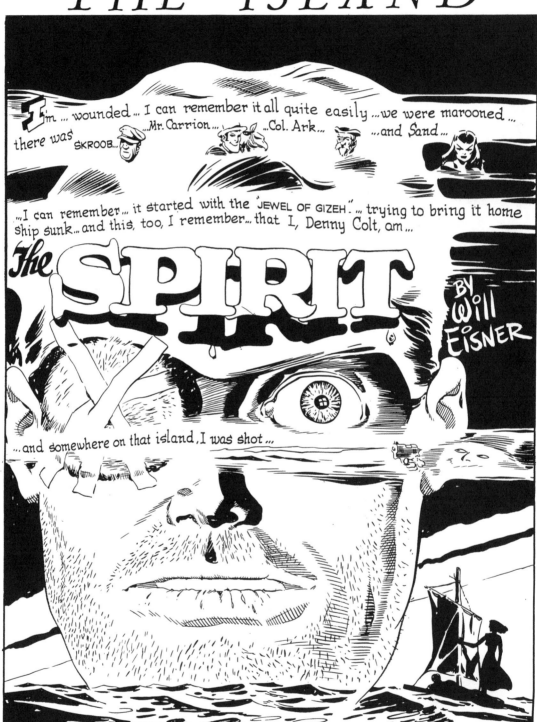

Originally published March 26, 1950

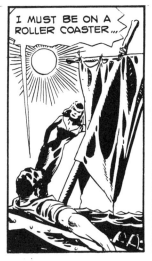

I MUST BE ON A ROLLER COASTER...

SURE...THAT'S IT! I'M IN CENTRAL CITY AND I'M RIDING ON A ROLLER COASTER...

WATER—

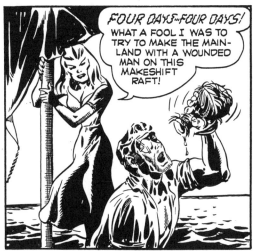

FOUR DAYS...FOUR DAYS! WHAT A FOOL I WAS TO TRY TO MAKE THE MAIN-LAND WITH A WOUNDED MAN ON THIS MAKESHIFT RAFT!

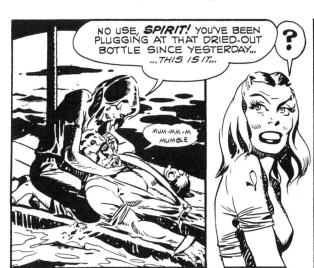

NO USE, SPIRIT! YOU'VE BEEN PLUGGING AT THAT DRIED-OUT BOTTLE SINCE YESTERDAY... ...THIS IS IT...

MUM~MM-M MUMBLE

?

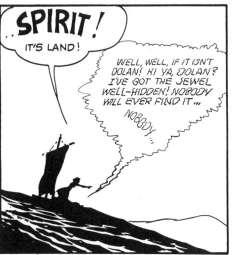

..SPIRIT! IT'S LAND!

WELL, WELL, IF IT ISN'T DOLAN! HI YA, DOLAN? I'VE GOT THE JEWEL WELL-HIDDEN! NOBODY WILL EVER FIND IT...

NOBODY...

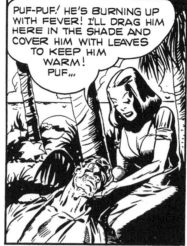

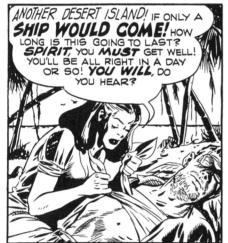

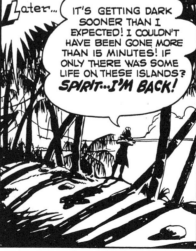

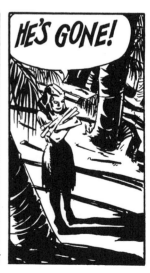

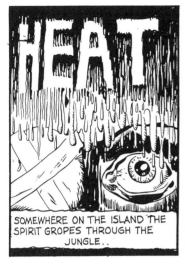

HEAT

SOMEWHERE ON THE ISLAND THE
SPIRIT GROPES THROUGH THE
JUNGLE..

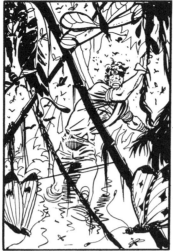

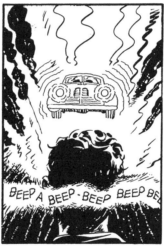

BEEP A BEEP - BEEP BEEP BE

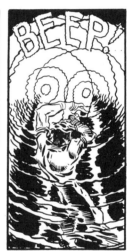

BEEP!

BEEP BEEP BEEP

BEEP BEEP
BEEP BEEP

WELL,
WELL,
WELL,
WELL,
WELL!

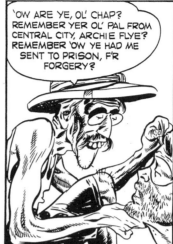

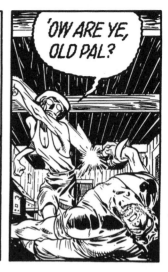

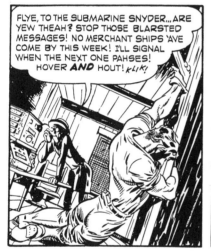

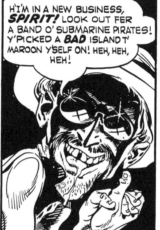

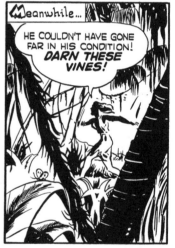

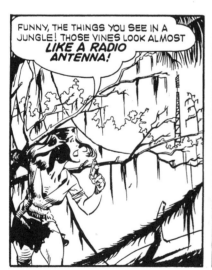

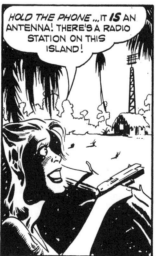

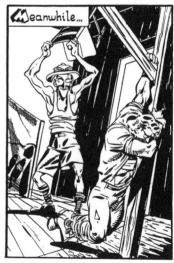

FALL, BLAST Y'R HIDE, FALL!

THAT'LL BE ALL, MISTER... GET AWAY FROM THE *SPIRIT* AND PUT YOUR HANDS UP!

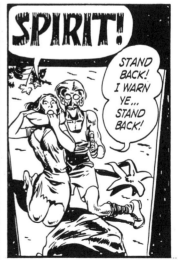

SPIRIT!

STAND BACK! I WARN YE... STAND BACK!

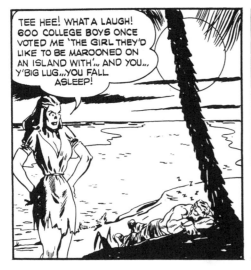

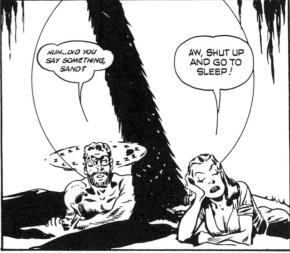

Stories can be hinged on a joke. Structurally, a joke is the dramatization of a surprise. An incongruous outcome of an act or speech, it can be either in dialogue form or presented as an incident. It is the unforeseen and unexpected which evokes the pleasure of relief or amusement that results in laughter.

In telling a joke, the storyteller should concentrate on staging the action or setting on which the joke depends. The reader is led up a path which veers away suddenly. While the point can be told in one or two written lines, the comics story-teller must flesh out a scenario that will accommodate graphics. This is done by adding background before and after the point. Vaudeville comedians called this "milking" a joke.

In this type of story, a prologue is necessary. This allows the comics story-teller to employ graphic devices to convey "flashback" as well as to intensify the reactions of the individuals involved. Text alone is not enough to sustain the ambiance of the graphic narrative. The telling of a joke with graphics requires that the storyteller maintain absolute control of the imagery. It becomes neces-sary, therefore, to avoid subtlety in art and to depend on stereotypes and easily recognized images.

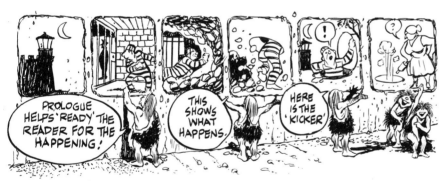

THE STRUCTURE OF A GRAPHICALLY TOLD
JOKE HAS A DEFINABLE ARCHITECTURE

In the following story, the "joke" is simple. A former hit man attempts to ful-fill a contract fifty years after the date he was employed to execute it. In doing so, he dies of a heart attack. His victim survives unaware that he was about to be assassinated by a friend. The joke is in the irony of the surprising pity he feels for the hit man, and the final line, "living is a risky business," is designed to make the point.

103

Ideas

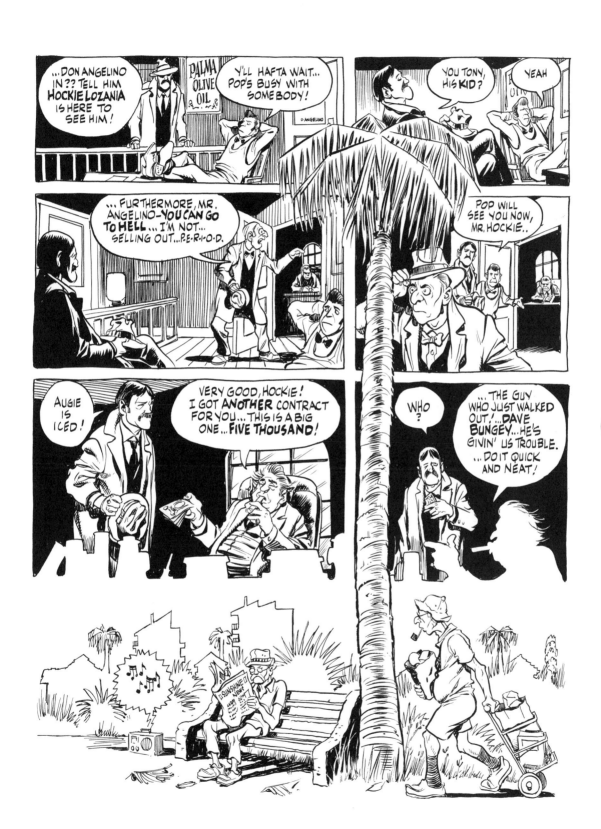

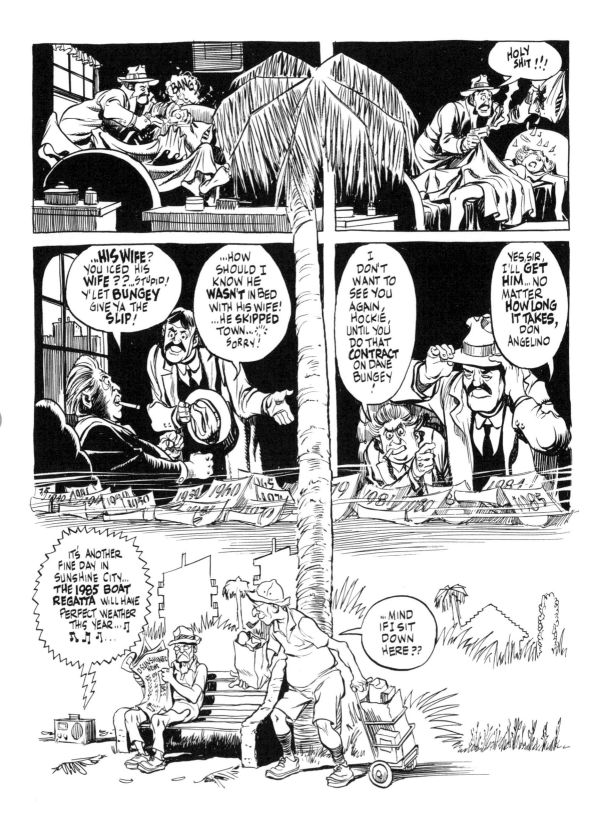

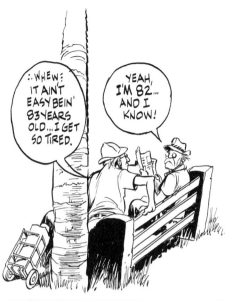

:WHEW: IT AIN'T EASY BEIN' 83 YEARS OLD... I GET SO TIRED.

YEAH, I'M 82... AND I KNOW!

USTA BE, I WUS ABLE TO UNLOAD 200 CASES OF OLIVE OIL IN **ONE** AFTERNOON!

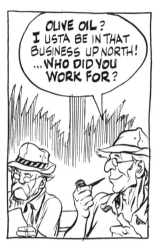

OLIVE OIL? I USTA BE IN THAT BUSINESS UP NORTH! ...WHO DID YOU WORK FOR?

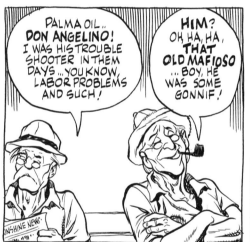

PALMA OIL... **DON ANGELINO!** I WAS HIS TROUBLE SHOOTER IN THEM DAYS... YOU KNOW LABOR PROBLEMS AND SUCH!

HIM? OH, HA, HA, **THAT OLD MAFIOSO** ...BOY, HE WAS SOME GONNIF!

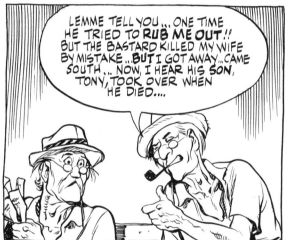

LEMME TELL YOU... ONE TIME HE TRIED TO **RUB ME OUT!!** BUT THE BASTARD KILLED MY WIFE BY MISTAKE...**BUT** I GOT AWAY...CAME SOUTH... NOW, I HEAR HIS **SON**, TONY, TOOK OVER WHEN HE DIED....

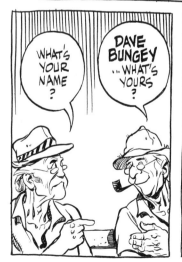

WHAT'S YOUR NAME?

DAVE BUNGEY ...WHAT'S YOURS?

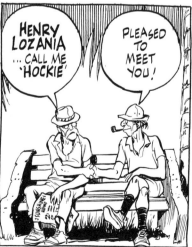

HENRY LOZANIA ...CALL ME 'HOCKIE'

PLEASED TO MEET YOU!

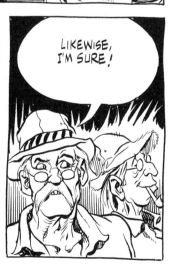

LIKEWISE, I'M SURE!

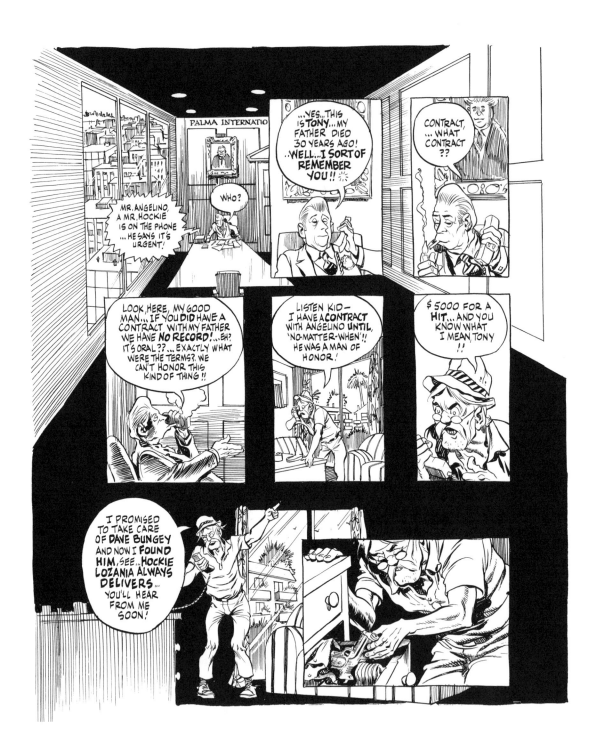

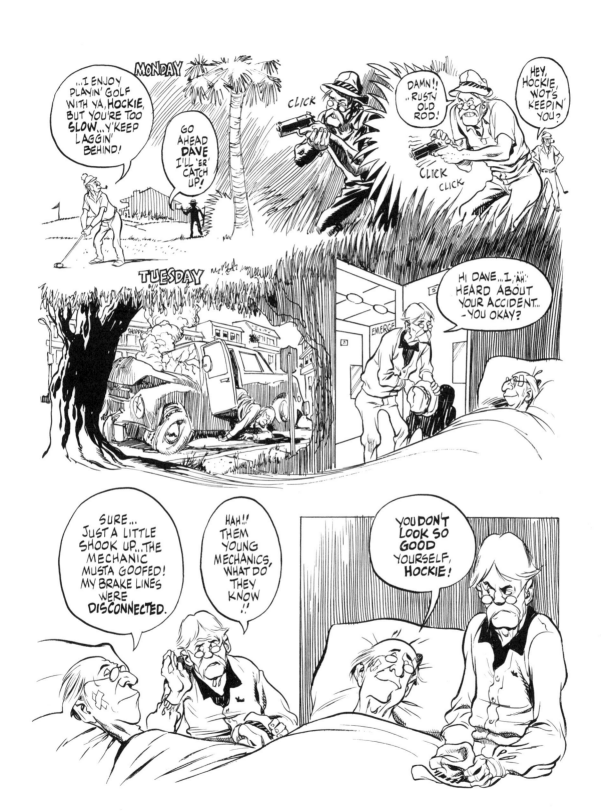

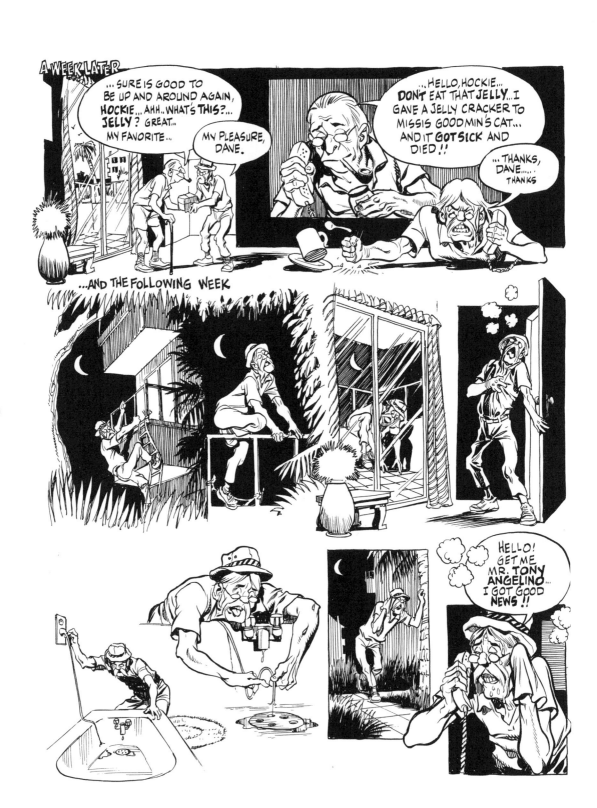

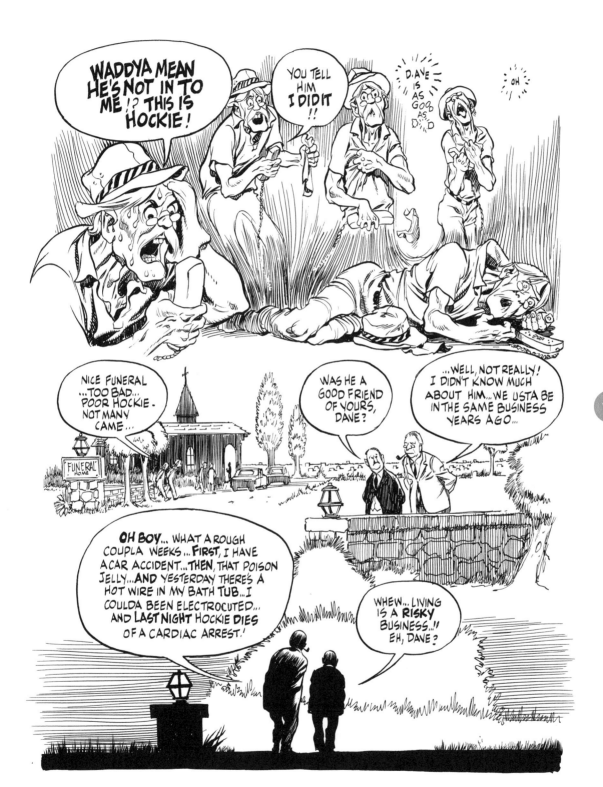

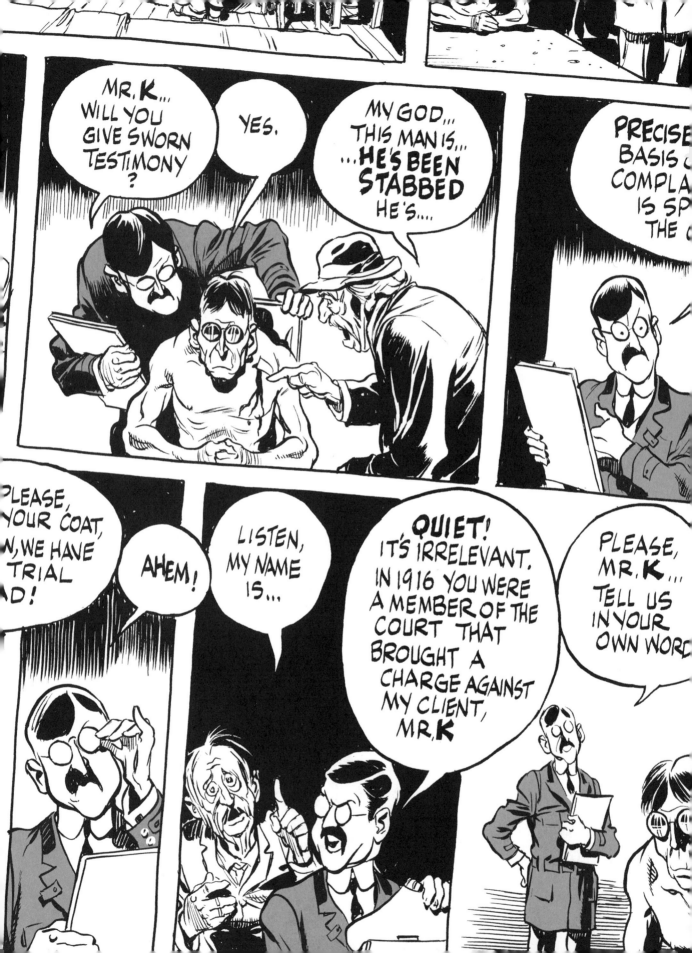

CHAPTER 9

THE WRITING PROCESS

Writing is commonly perceived as confined to the manipulation of words. The process of writing for graphic narration concerns itself with the development of the concept, then the description of it and the construction of the narrative chain in order to translate it into imagery. The dialogue supports the imagery—both are in service to the story. They combine and emerge as a seamless whole. The *ideal* writing process occurs where the writer and artist are the same person. This, in effect, *shortens* the distance between the idea and its translation. It produces a product that more closely reflects the intent of the writer.

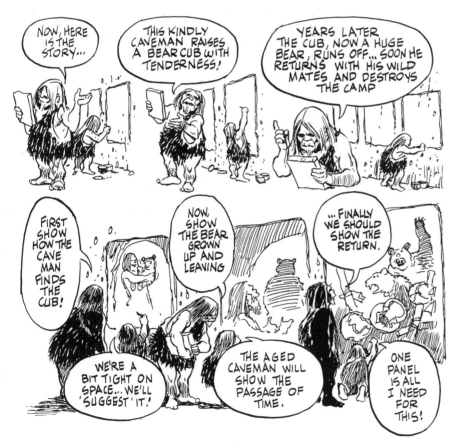

In theater or film, the script falls into the hands of directors, actors, cameramen and other technicians. In comics, the writing will be "broken down" into panels and pages by one or more artists. In some cases a "breakdown" or roughly sketched interpretation acts as a blueprint.

There is a distinct difference between writing for a book of text and a graphic novel. For one thing, a type font has no involvement in the nature, structure or quality of a story. Type does not translate; images do.

Writing that is translated into graphic dramatization, whether film or comics, must adapt to the mechanics of the form. For example, writing for film or comics is economical, eschews literary style, and does not need descriptive passages that evoke images by analogous prose. The *idea* is the dominant element. Often a writer will reinforce the translation process by supplying "depth" descriptions not intended to be reproduced, but rather designed to give the artist guidance.

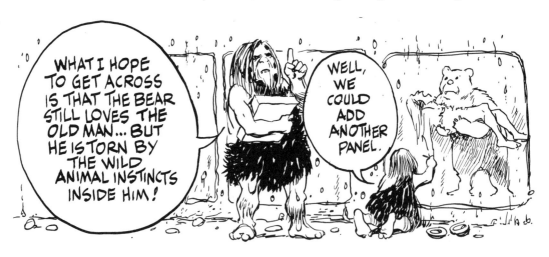

In effect, writing in the graphic medium means writing for the artist. The writer supplies the concept, plot and cast of characters. His dialogue (in balloons) is addressed to the reader, but the description of the action is addressed to the graphic translator.

A script for comics that describes the psychological nuances of a character does so with the hope that the artwork will adequately convey such internalization.

Here, for example, is the task facing a translating artist who must deal with the following script (panel one, page one) of a ten-page, high-action crime story built mainly on pursuit.

PANEL ONE

SCENE

The detective enters from the left. He limps a bit (an old war wound) and favors the leg. His craggy face is a tale of years of struggle, pain and disappointment. His eyes are cold blue steel and with a swift jungle animal scan, they sweep the room. This man has killed. He is seething with rage at the humiliation of being called in so late to the case. He masks his anger but not his twitching jaw muscles.

Show middle distance shot slightly from above with Commissioner and other officers standing awkwardly against the office wall.

BALLOON

DICK: "Well Sir I got your call. If you expect me to tidy up a mess, you'd better put those clerks into storage."
COMMISH: "Now Dick, this is a very touchy situation."

The script provides the artist with an internal view of the detective in the hope that the character can be limned well enough to imply all that the writer hopes to convey. But we know that to portray things like "an old war wound," "eyes sweeping the room," "seething rage," "humiliation" and "working jaw muscles" may not be possible in a single middle-shot panel.

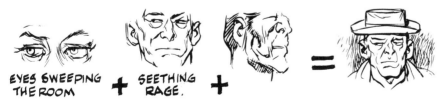

What is the writer asking for? Is the writer willing to permit these characteristics to be "divined" by the reader, or is it critical to the story that they be clearly shown?

The artist is faced with a translation dilemma. How important are the "twitching jaw muscles" and the other subtle characteristics? Indeed, how much needs to be shown in one panel? It is, of course, possible to ultimately convey the detective's persona by small inferences in successive panels, providing that fast-paced action does not interfere. Another accommodation is to insert a narrative panel that shows the subtle sub-surface characteristics. All of this depends on space.

As this example demonstrates, graphic narrative writing must deal with the limitations of the medium as well as the interpretation of the artist.

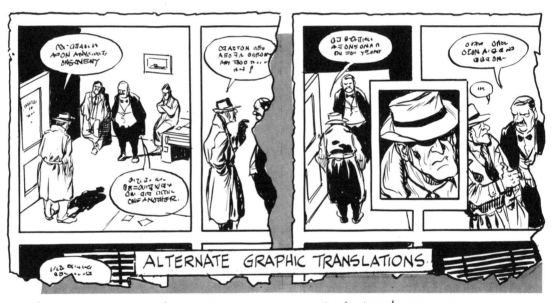

THIS ADHERES TO THE SCRIPT BUT IT OBVIOUSLY CANNOT CLEARLY DELIVER THE NUANCES REQUIRED

IF THE HERO'S PERSONALITY IS CRITICAL TO THE PLOT—IT CAN BE DELIVERED BY ADDING PANELS

Comics is a medium confined to still images, bereft of sound and motion, and writing must accommodate these restrictions.

Writers must also factor into their expectations the skills of the artist. The artist or the writer (or both) are challenged by the need to convey "internals." Subtle gestures or provocative postures are not easy to depict without the continuing movement afforded by film. In this medium "telling" images must be extracted from the flow of action and then frozen.

Another example of writing that runs afoul of the medium's limitations is the following passage:

"The detective dropped gracefully through the manhole into a space between the crates of ammunition. He would wait there until the killers brought their prisoner into a space lit by an anemic 40-watt bulb at the end of the room.

"His mind rewound. It was Vietnam again. The Delta was still. He was wondering whether the beating of his heart could be heard as he waited behind the boxes of 50-caliber rounds. The months of basic back at Parris Island really hadn't prepared him for this. Ah yes, in the barrio—where he misspent his preschool years—was more like it. His 'big brother' taught him well. 'Paulo, when you drop from the fire escape, freeze. Do not even wiggle your ass. You stay in the alley behind the garbage can until they come into the light. Those T-bones, they can smell you.'

"The door's slam wiped out his reverie. Suddenly he was alert. He peered around the box ready to spring. Then, the cold steel mouth of an automatic pressing against the nape of his neck brought him slowly upright."

For the storyteller to translate this narrative to graphics, a decision about how to deal with the flashback must be made during the *breakdown* stage. The writer must know that to show a replay of memory will require space. Flashbacks can also slow the action. In this case, the amount of space, allocated in the breakdown, will determine how much narrative to eliminate.

Imagine for this purpose you are the artist and you must translate this passage into a graphic narrative: How many panels would you devote to paragraph one? Yes, it would be easy to show the detective dropping through the manhole—but how would you convey the idea that he was going down to await the killers and their prisoner? How many panels would you devote to this?

In the second paragraph, the reader is invited to tour the man's past. There's a lot of story here. How do you keep it from slowing the action—that is, keep the story flow alive? The third paragraph is a problem in posture and gesture.

There are instances where narrative text is integral to the graphic. In such a case, the art becomes only an illustration in support of the text. Here is an example of a fantasy story in which text carries the flashback. In doing so it becomes integral to the method of narration.

> THERE ARE INSTANCES WHERE NARRATIVE TEXT IS INTEGRAL TO THE GRAPHIC.

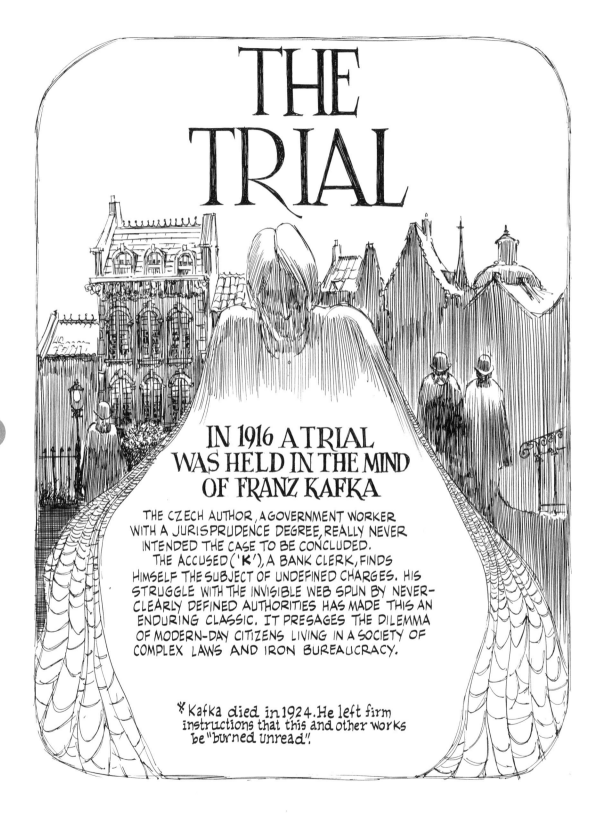

THE TRIAL

IN 1916 A TRIAL WAS HELD IN THE MIND OF FRANZ KAFKA

THE CZECH AUTHOR, A GOVERNMENT WORKER WITH A JURISPRUDENCE DEGREE, REALLY NEVER INTENDED THE CASE TO BE CONCLUDED.

THE ACCUSED ('K'), A BANK CLERK, FINDS HIMSELF THE SUBJECT OF UNDEFINED CHARGES. HIS STRUGGLE WITH THE INVISIBLE WEB SPUN BY NEVER-CLEARLY DEFINED AUTHORITIES HAS MADE THIS AN ENDURING CLASSIC. IT PRESAGES THE DILEMMA OF MODERN-DAY CITIZENS LIVING IN A SOCIETY OF COMPLEX LAWS AND IRON BUREAUCRACY.

* Kafka died in 1924. He left firm instructions that this and other works be "burned unread".

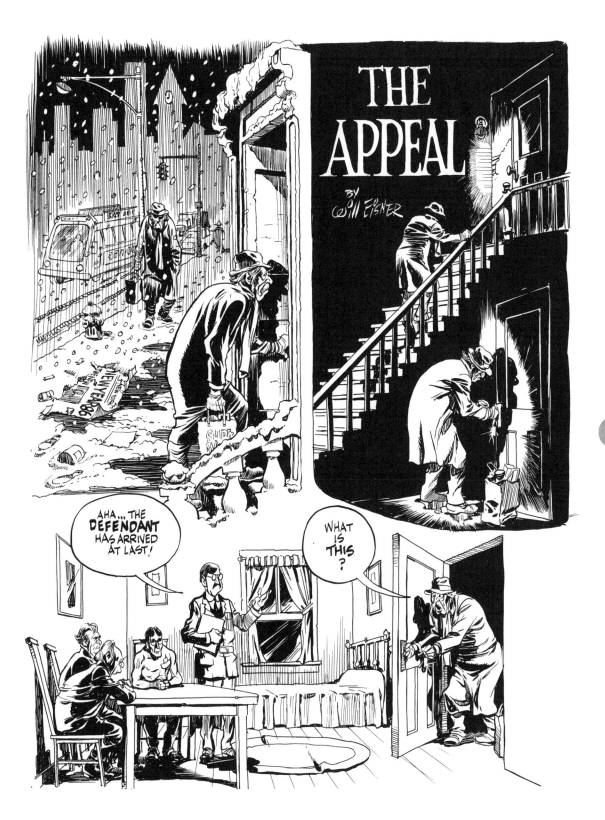

WHO **ARE YOU**? THIS IS **MY** ROOM! HOW DID YOU GET IN HERE?

PLEASE... CONDUCT YOURSELF IN A VERY CIVILIZED MANNER! WE ARE TRYING TO PROCEED WITH A **TRIAL** HERE

AHEM...THE APPELLATE BRANCH OF THE TENTH COURT OF PRAGUE IS IN SESSION...THE **PLAINTIFF** IS MR.**K**... THE OTHERS ARE THE JURY!

THIS IS **ABSURD**. WHO ARE YOU?

I AM THE ATTORNEY FOR THE PLAINTIFF.

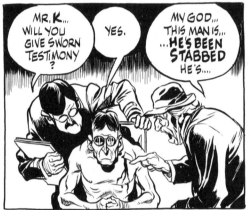

MR. **K**... WILL YOU GIVE SWORN TESTIMONY?

YES.

MY GOD... THIS MAN IS... ...**HE'S BEEN STABBED** HE'S....

PRECISELY!... IT IS THE BASIS OF MY CLIENT'S COMPLAINT...BUT, THAT IS SPECIFIED IN THE CHARGES!

I CAN'T BELIEVE THIS!

NOW, PLEASE, REMOVE YOUR COAT, COME NOW, WE HAVE A LONG TRIAL AHEAD!

AHEM!

LISTEN, MY NAME IS...

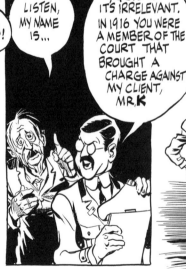

QUIET! IT'S IRRELEVANT. IN 1916 YOU WERE A MEMBER OF THE COURT THAT BROUGHT A CHARGE AGAINST MY CLIENT, MR.**K**

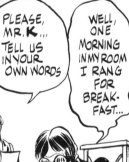

PLEASE, MR. **K**... TELL US IN YOUR OWN WORDS

WELL, ONE MORNING IN MY ROOM I RANG FOR BREAKFAST...

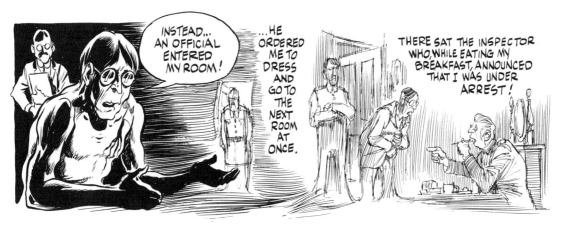

INSTEAD... AN OFFICIAL ENTERED MY ROOM!

...HE ORDERED ME TO DRESS AND GO TO THE NEXT ROOM AT ONCE.

THERE SAT THE INSPECTOR WHO, WHILE EATING MY BREAKFAST, ANNOUNCED THAT I WAS UNDER ARREST!

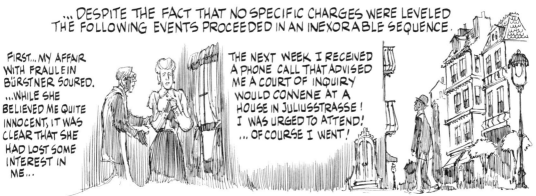

...DESPITE THE FACT THAT NO SPECIFIC CHARGES WERE LEVELED THE FOLLOWING EVENTS PROCEEDED IN AN INEXORABLE SEQUENCE.

FIRST... MY AFFAIR WITH FRAULEIN BÜRSTNER SOURED. ...WHILE SHE BELIEVED ME QUITE INNOCENT, IT WAS CLEAR THAT SHE HAD LOST SOME INTEREST IN ME...

THE NEXT WEEK I RECEIVED A PHONE CALL THAT ADVISED ME A COURT OF INQUIRY WOULD CONVENE AT A HOUSE IN JULIUSSTRASSE! I WAS URGED TO ATTEND! ...OF COURSE I WENT!

121

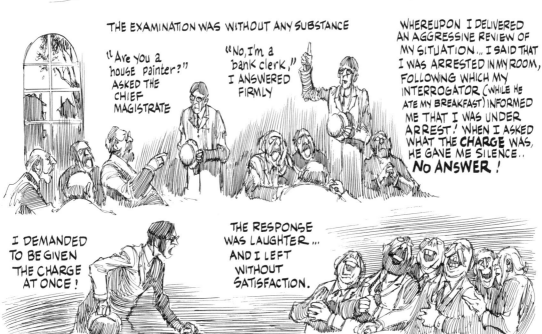

THE EXAMINATION WAS WITHOUT ANY SUBSTANCE

"Are you a house painter?" ASKED THE CHIEF MAGISTRATE

"No, I'm a bank clerk," I ANSWERED FIRMLY

WHEREUPON I DELIVERED AN AGGRESSIVE REVIEW OF MY SITUATION ... I SAID THAT I WAS ARRESTED IN MY ROOM, FOLLOWING WHICH MY INTERROGATOR (WHILE HE ATE MY BREAKFAST) INFORMED ME THAT I WAS UNDER ARREST! WHEN I ASKED WHAT THE **CHARGE** WAS, HE GAVE ME SILENCE... NO ANSWER!

I DEMANDED TO BE GIVEN THE CHARGE AT ONCE!

THE RESPONSE WAS LAUGHTER ... AND I LEFT WITHOUT SATISFACTION.

WELL, THE MATTER WAS FAR FROM CLOSED, I CAN TELL YOU... WHEN ONE HAS A CHARGE LEVELED AGAINST HIM IT CAN BE QUITE A BURDEN... MY WORK AT THE BANK WAS SUFFERING... I HAD NO CHOICE BUT TO CONFRONT IT...

I WENT TO MY UNCLE KARL. HE FEARED THAT THE FAMILY WOULD BECOME INVOLVED. THIS LED HIM TO SECURE FOR ME A **LAWYER**, NAMED FULD WHO WAS, HIMSELF, QUITE SICK... BUT IT WAS HIS WOMAN AIDE (**LENI**) WHO ADVISED ME THAT UNLESS I WOULD PLEAD GUILTY – THEY COULD NOT HELP... I REFUSED!

I TRIED ALL AVENUES... I APPEALED TO THE **PAINTER** WHO HAD A STUDIO BEHIND WHICH WAS THE COURT.... TO NO AVAIL! NEXT, I **DISMISSED** MY LAWYER AND APPLIED TO A MR. BLOCK WHO ADVISED ME AGAINST ANY INDEPENDENT ACTION. FINALLY....I MET WITH A **PRIEST**... A FUTILE MEETING! IN THE END NEITHER MY INNOCENCE NOR GUILT WAS RESOLVED.

FINALLY... ON THE EVE OF MY 31ST BIRTHDAY... AT ABOUT NINE P.M., I RECEIVED TWO VISITORS

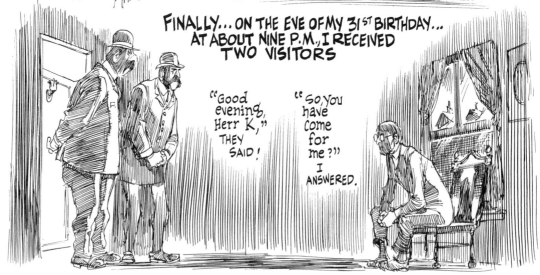

"Good evening, Herr K," THEY SAID!

"So, you have come for me?" I ANSWERED.

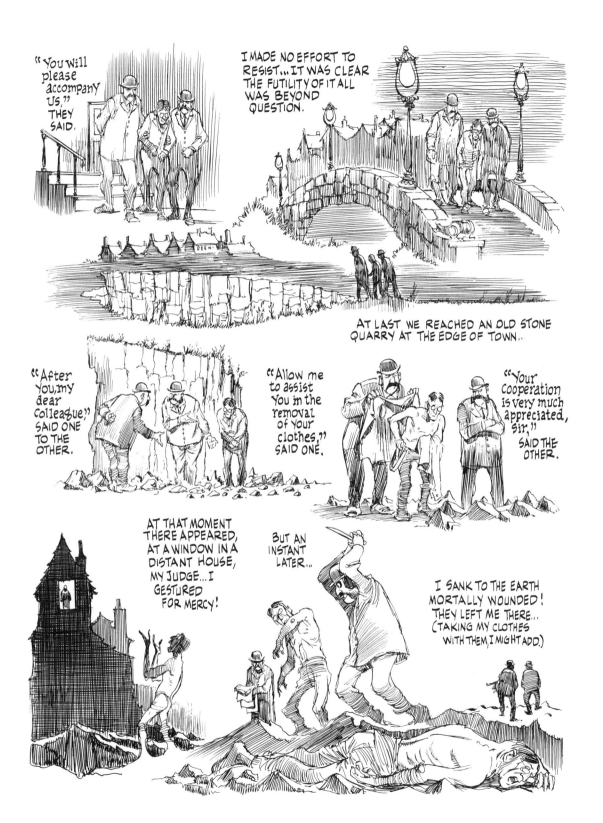

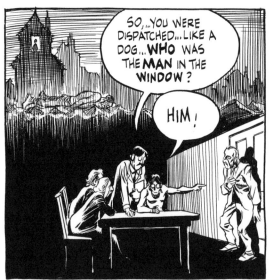

SO,...YOU WERE DISPATCHED...LIKE A DOG...**WHO** WAS THE **MAN** IN THE WINDOW?

HIM!

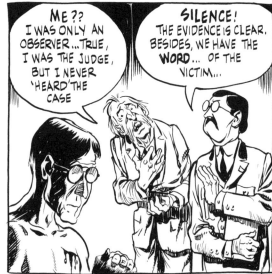

ME?? I WAS ONLY AN OBSERVER...TRUE, I WAS THE JUDGE, BUT I NEVER 'HEARD' THE CASE

SILENCE! THE EVIDENCE IS CLEAR. BESIDES, WE HAVE THE **WORD**... OF THE VICTIM...

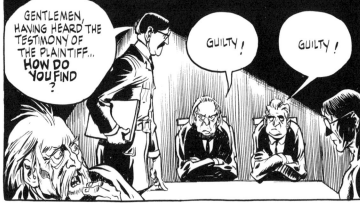

GENTLEMEN, HAVING HEARD THE TESTIMONY OF THE PLAINTIFF... **HOW DO YOU FIND**?

GUILTY!

GUILTY!

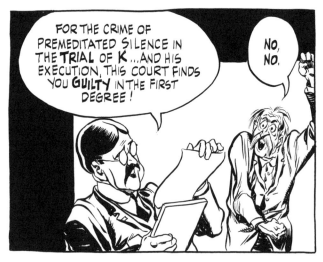

FOR THE CRIME OF PREMEDITATED SILENCE IN THE **TRIAL** OF **K**...AND HIS EXECUTION, THIS COURT FINDS YOU **GUILTY** IN THE FIRST DEGREE!

NO, NO.

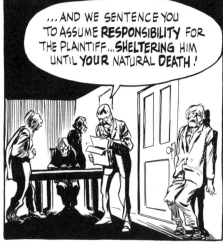

...AND WE SENTENCE YOU TO ASSUME **RESPONSIBILITY** FOR THE PLAINTIFF...**SHELTERING** HIM UNTIL **YOUR** NATURAL **DEATH**!

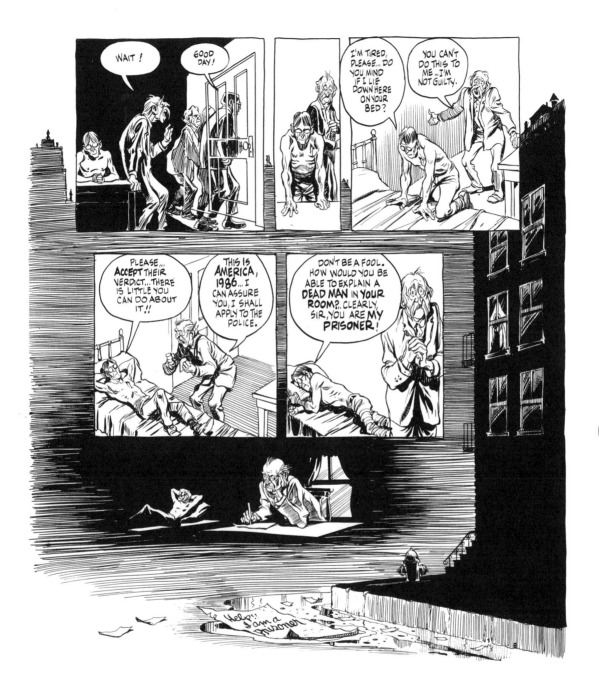

Not surprisingly, there often are communication problems between participants in the process of graphic storytelling.

In writing for graphic storytelling, the ultimate judgment of the narrative is made after the work is translated into art. The writer, therefore, must be aware of the obstacles on the way to publication.

When text alone is the vehicle in conveying a story to the reader, there is little chance of a misperception. But from text to visual, there is a high probability of a difference in outcome, stemming from lack of skill to lack of time. In this medium, storytelling is not always a straight line from the mind to the reader. Here is what often happens.

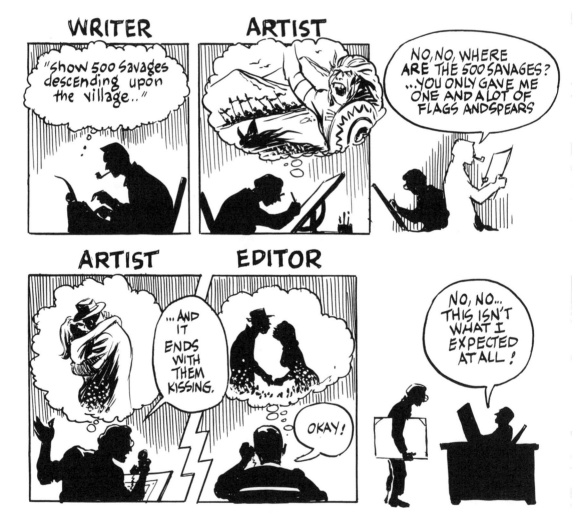

CHAPTER 10
STORYTELLERS

In the comics medium, the continuing adventure narrative first appeared in the daily newspaper strips. This was feasible because until the 1930s, newspapers dominated popular reading and were a regular uninterrupted family companion. In those years, there was fierce competition on the newsstands and comics, particularly continuity strips, held the loyalty of readers. This required storytelling skills.

In 1934, Milton Caniff (in those days most cartoonists wrote and drew their own strips) began *Terry and the Pirates*. This strip went beyond the daily joke format and purported to be a never-ending story. Caniff was carrying forward the "adventure" theme that Lyman Young began in *Tim Tyler's Luck* a few years previous. Caniff not only brought sophisticated art to the medium but his storytelling, albeit parsed out daily in segments, was so sturdy that it was usable material for the aborning comic books.

In his book, *The Art of the Funnies,* R. C. Harvey credits Caniff with "virtually redefining the adventure strip by infusing exotic tales with palpable realism. As a storyteller he enhanced the traditional formula by incorporating character development into action-packed plots."

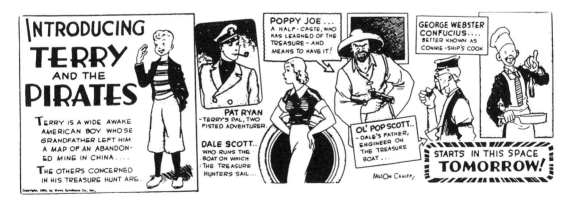

The introductory strip for *Terry and the Pirates* (1934) laid out the cast of characters and set the story track. In later sequences (1935), Caniff demonstrates his brilliant control of storytelling. Remember, a full day elapsed between each strip, yet he never lost his readers.

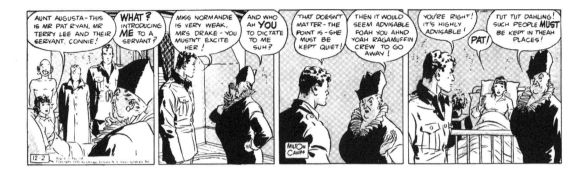

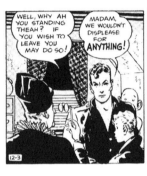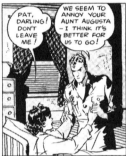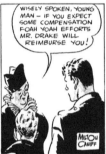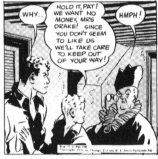

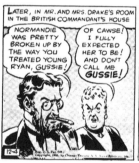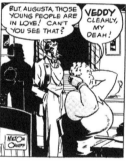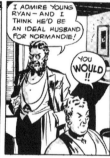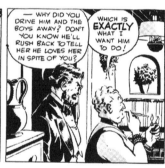

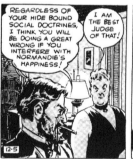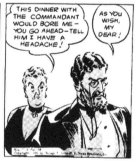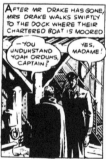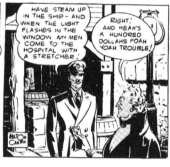

Graphic Storytelling and Visual Narrative

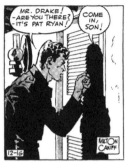

MR. DRAKE! -ARE YOU THERE? -IT'S PAT RYAN!

COME IN, SON!

12-16

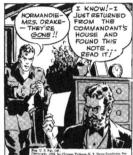

NORMANDIE-MRS. DRAKE- THEY'RE GONE !!

I KNOW!-I JUST RETURNED FROM THE COMMANDANT'S HOUSE AND FOUND THIS NOTE... READ IT!

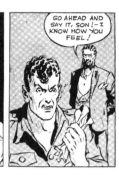

Chauncey——
Since you did not see fit to aid me in protecting Normandie from that fortune hunter, Ryan, I have taken matters into my own hands.

By the time you receive this we shall be on the high seas, bound for the United States.

Inform Ryan that if he attempts to communicate with Normandie in any way I will have him prosecuted as an extortionist. Augusta

GO AHEAD AND SAY IT, SON!-I KNOW HOW YOU FEEL!

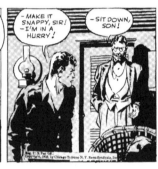

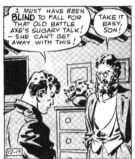

I MUST HAVE BEEN BLIND TO FALL FOR THAT OLD BATTLE AXE'S SUGARY TALK! — SHE CAN'T GET AWAY WITH THIS!

TAKE IT EASY, SON!

12-17

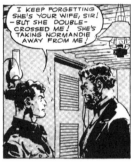

I KEEP FORGETTING SHE'S YOUR WIFE, SIR! — BUT SHE DOUBLE-CROSSED ME! SHE'S TAKING NORMANDIE AWAY FROM ME!

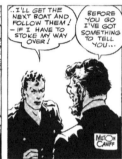

..I'LL GET THE NEXT BOAT AND FOLLOW THEM! — IF I HAVE TO STOKE MY WAY OVER!

BEFORE YOU GO I'VE GOT SOMETHING TO TELL YOU...

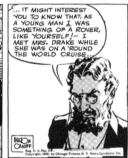

— MAKE IT SNAPPY, SIR! — I'M IN A HURRY!

— SIT DOWN, SON!

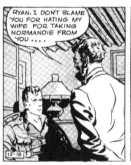

RYAN, I DON'T BLAME YOU FOR HATING MY WIFE FOR TAKING NORMANDIE FROM YOU

12-18

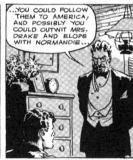

..YOU COULD FOLLOW THEM TO AMERICA, AND POSSIBLY YOU COULD OUTWIT MRS. DRAKE AND ELOPE WITH NORMANDIE...

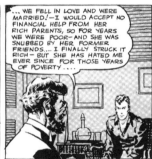

..IT MIGHT INTEREST YOU TO KNOW THAT, AS A YOUNG MAN I WAS SOMETHING OF A ROVER, LIKE YOURSELF!— I MET MRS. DRAKE WHILE SHE WAS ON A 'ROUND THE WORLD CRUISE...

... WE FELL IN LOVE AND WERE MARRIED!—I WOULD ACCEPT NO FINANCIAL HELP FROM HER RICH PARENTS, SO FOR YEARS WE WERE POOR—AND SHE WAS SNUBBED BY HER FORMER FRIENDS.... I FINALLY STRUCK IT RICH—BUT SHE HAS HATED ME EVER SINCE FOR THOSE YEARS OF POVERTY

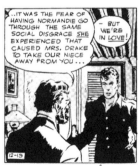

..IT WAS THE FEAR OF HAVING NORMANDIE GO THROUGH THE SAME SOCIAL DISGRACE SHE EXPERIENCED THAT CAUSED MRS. DRAKE TO TAKE OUR NIECE AWAY FROM YOU ...

— BUT WE'RE IN LOVE!

12-19

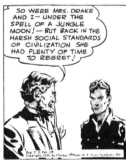

SO WERE MRS. DRAKE AND I — UNDER THE SPELL OF A JUNGLE MOON! — BUT BACK IN THE HARSH SOCIAL STANDARDS OF CIVILIZATION SHE HAD PLENTY OF TIME TO REGRET!

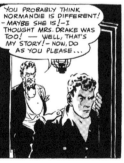

YOU PROBABLY THINK NORMANDIE IS DIFFERENT! — MAYBE SHE IS!—I THOUGHT MRS. DRAKE WAS TOO! — WELL, THAT'S MY STORY!—NOW, DO AS YOU PLEASE...

Storytellers

By 1957, Caniff's storytelling had matured, as this short sequence from *Steve Canyon* shows. He demonstrates here a well-controlled flow of story that sustains its connection between strips. His plots are played out with panels that are mostly standard so that they do not intr ude graphically. This enhances the flow of the narrative and forces concentration on the actors. In this story, his action-filled episodes accelerate the rhythm of the strip yet allow the dialogue to retain its meter. He uses wordless panels masterfully and composes them so that they invite the reader to participate in the "acting."

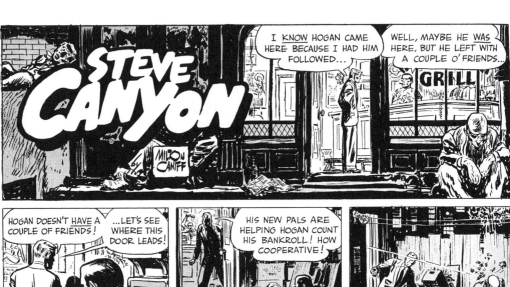

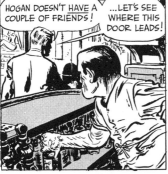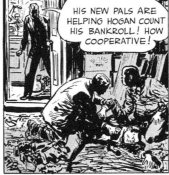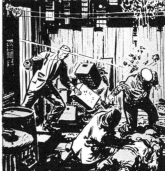

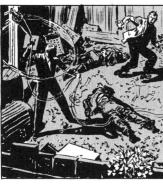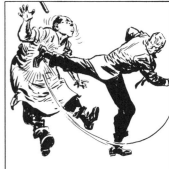

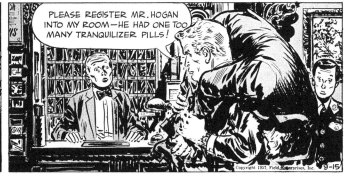

PLEASE REGISTER MR. HOGAN INTO MY ROOM—HE HAD ONE TOO MANY TRANQUILIZER PILLS!

Copyright 1957, Field Enterprises, Inc. 9-15

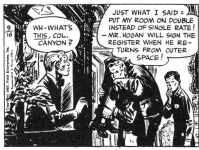

WH—WHAT'S THIS, COL. CANYON?

JUST WHAT I SAID = PUT MY ROOM ON DOUBLE INSTEAD OF SINGLE RATE! — MR. HOGAN WILL SIGN THE REGISTER WHEN HE RETURNS FROM OUTER SPACE!

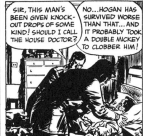

SIR, THIS MAN'S BEEN GIVEN KNOCK-OUT DROPS OF SOME KIND! SHOULD I CALL THE HOUSE DOCTOR?

NO...HOGAN HAS SURVIVED WORSE THAN THAT... AND IT PROBABLY TOOK A DOUBLE MICKEY TO CLOBBER HIM!

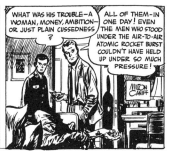

WHAT WAS HIS TROUBLE—A WOMAN, MONEY, AMBITION—OR JUST PLAIN CUSSEDNESS?

ALL OF THEM—IN ONE DAY! EVEN THE MEN WHO STOOD UNDER THE AIR-TO-AIR ATOMIC ROCKET BURST COULDN'T HAVE HELD UP UNDER SO MUCH PRESSURE!

MILTON CANIFF

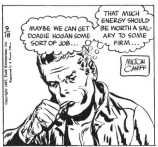

WONDER WHAT HOGAN IS DREAMING ABOUT—THE STUBBORN MUGG...

...HE'S THE SORT OF TOUGH JOKER WHO WINS HERO MEDALS— THEN CAN'T ADJUST TO PEACE! ...HE ALWAYS HAS TO BE FIGHTING WITH SOMEONE!

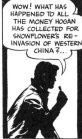
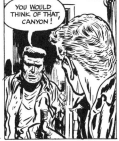

HE PROBABLY REALLY BELIEVED HE COULD INVADE WESTERN CHINA AND PUT PRINCESS SNOW-FLOWER BACK ON HER THRONE!...

I'M SURE HE DIDN'T EVEN THINK ONCE THAT HE COULD TRIGGER WORLD WAR III AND START THE KILLING OF A FEW MILLION PEOPLE!

MILTON CANIFF

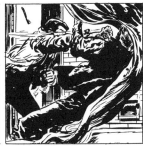
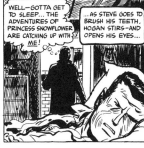

WELL—GOTTA GET TO SLEEP... THE ADVENTURES OF PRINCESS SNOWFLOWER ARE CATCHING UP WITH ME!

...AS STEVE GOES TO BRUSH HIS TEETH, HOGAN STIRS—AND OPENS HIS EYES...

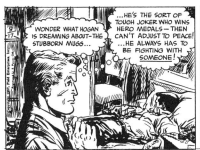

MAYBE WE CAN GET DOAGIE HOGAN SOME SORT OF JOB...

THAT MUCH ENERGY SHOULD BE WORTH A SALARY TO SOME FIRM...

MILTON CANIFF

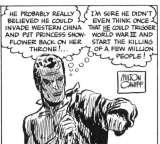

WOW! WHAT HAS HAPPENED TO ALL THE MONEY HOGAN HAS COLLECTED FOR SNOWFLOWER'S RE-INVASION OF WESTERN CHINA?...

YOU WOULD THINK OF THAT, CANYON!

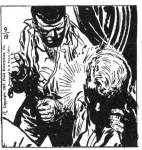

MILTON CANIFF

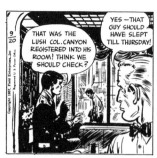
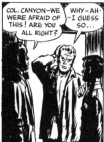
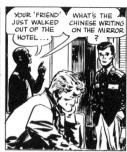
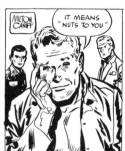

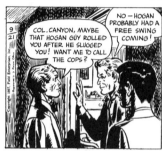
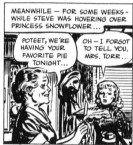
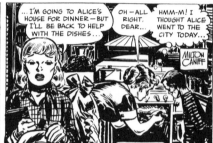

There is a major structural difference between newspaper storytelling strips and comic books. In comic books, stories come to a definite conclusion, a tradition that began when the early comic books advertised that each story was complete. A book is free-standing, whereas newspapers are connected to the pattern of daily life. In a daily continuity, therefore, the storyteller need only segue into the next adventure. Caniff understood that the story had to emulate the seamless flow of life's experiences and that the human adventure doesn't have neat endings. His work shows us how to tell a story that could make itself part of the reader's daily life.

THERE IS A MAJOR STRUCTURAL DIFFERENCE BETWEEN NEWSPAPER STORYTELLING STRIPS AND COMIC BOOKS.

THE SHORT SHORT PLOT

If stories can be extended, they can also be compressed. The success of such a shortening lies in the preservation of the essence. The major theme or plot must be preserved, and the collateral dramatization is cut to the bone. In this, the reader supplies the intervening action either by reflexive deduction or drawing from experience.

Ernest Hemingway narrated the shortest short story as follows: "For sale, baby shoes, never used." It would not be hard to write a larger story around this core. The power of this story lies in the skill with which the selection of the "touchstone" points are made. They co-opt the reader and immerse him or her in a sea of memory and experience. Cleverly, it forces the reader to "write" the story. The visual here is designed to evoke a setting.

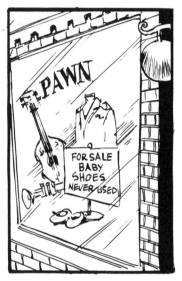

THE ONE-PAGE STORY

As early as 1916, George Herriman, the medium's most innovative storyteller, laid the tracks for the highly-condensed graphic narrative. With the *Krazy Kat* Sunday comics page, he demonstrated compact story delivery by deploying his images in a format that would influence generations of comics storytellers who came after him. The following is an example of this:

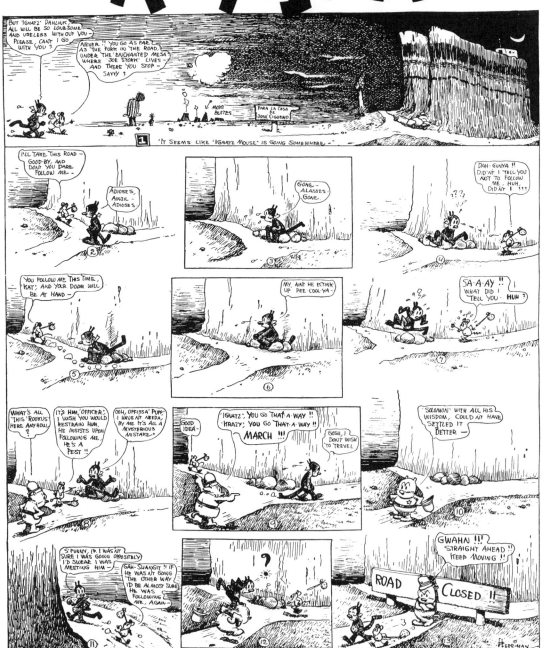

Riding the crest of the wave of adventure story comics, by 1937 the interest in well-drawn strips with good art opened up Sunday pages to established illustrators. Harold Foster, who for six years had produced a daily strip based on the popular *Tarzan* novels, switched to a story of his own. *Prince Valiant* is the story of a young knight in the days of King Arthur. It is peopled with characters drawn from legend and the books of Sir Walter Scott. *Prince Valiant* appeared only a year after the birth of the comic book, where complete stories were being told in the ever-refining sequential art form. In comic books, the trend was to have the story told with images and dialogue balloons with little narrative prose. Foster, however, employed the practice of traditional book illustration. In the literary world, classic book illustration was more highly regarded than comics. It did, after all, leave the text unmolested. The newspapers accommodated this reverence, hiring well-established artists to illustrate stories. The format was comic-related, but the storytelling depended mostly on text. Harold Foster, an accomplished artist, illustrated his stories with splendid, well-researched art that left a minimum of text to carry the thread.

Shortly after the feature began, he departed from the partnership of text and image principle so unique to comics. To maintain a story flow under these conditions is very difficult. An early episode demonstrates (note the reliance on numbered panels) his groping toward a sequential format to accommodate this kind of narrative. *Prince Valiant* is a classic example of narrative illustration that remains steadfastly in service to the story. It is reader friendly.

> IN STUDYING THE STORYTELLING PROCESS OF THIS FORM OF SEQUENTIAL ART, ONE SHOULD FIRST NOTE THE COMPOSITION OF EACH PANEL.

In studying the storytelling process of this form of sequential art, one should first note the composition of each panel. Foster maintained the narrative dominance of the art by illustrating the whole of the action. He deployed the actors in a manner similar to the required stagecraft in a sequenced comic. Throughout his stories, the main characters remained in the center of action and Foster avoided highly descriptive prose. Its brevity allowed him to employ art that told a great deal of story. The effectiveness of *Prince Valiant* as narrative illustration is demonstrated by its visual flow. The high degree of accuracy and detail should not be regarded as purely decorative; it is a major ingredient in storytelling.

"IF STORIES CAN BE EXTENDED, THEY CAN ALSO BE COMPRESSED."

MORE ADAPTATION THAN PARODY, R. SIKORYAK'S MASTERFUL COMICS GRAFT CLASSIC literature with iconic comics while somehow managing to be faithful to both sources. In this example, Sikoryak compresses Dante's epic poem, *The Inferno* (one of the three canticles that make up *The Divine Comedy*), into ten *Bazooka Joe* comic strips (in and of themselves an exercise in compression). *The Inferno* is brilliantly boiled down to its essence while the structure and intrinsic character of *Bazooka Joe* is also retained!

Prince Valiant

IN THE DAYS OF KING ARTHUR
BY HAROLD R. FOSTER

SYNOPSIS
THE PAUPER PRINCE CAPTURES AND TRAINS A WILD HORSE, CONSTRUCTS HIS OWN HARNESS AND LEATHERN ARMOR, THEN SETS OUT TO BECOME A KNIGHT. AFTER WANDERING INLAND FOR SOME DAYS HE IS OVERTAKEN BY SIR GAWAIN, A KNIGHT OF THE ROUND TABLE. — 1

IMPRESSED ALIKE BY VAL'S FEARLESS BEARING AND THE SMELL OF HIS COOKING, SIR GAWAIN ALIGHTS. — 2

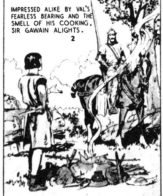

FROM HIS CONVERSATION VAL LEARNS MUCH OF THE LIFE AND DUTIES OF A KNIGHT. — 3

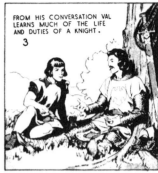

AN ARMED KNIGHT AND HIS SQUIRE COME UP BEHIND THEM — QUIETLY. — 4

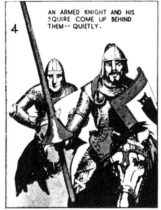

"'TIS SIR NEGARTH, A ROBBER KNIGHT," SAID SIR GAWAIN RECOGNIZING HIM AND REACHING FOR HIS SWORD. — 5

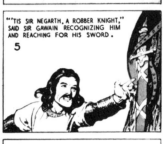

BUT BEFORE HE COULD DRAW THE FALSE KNIGHT STRIKES HIM DOWN WITH HIS MACE! — 6

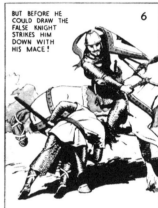

"STRIP HIM AND LOAD HIS GEAR ON HIS HORSE." — 7

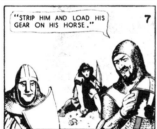

NOT THE PROPER WAY TO VANQUISH A KNIGHT, BUT QUITE EFFECTIVE. — 8

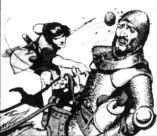

PRINCE VAL NEATLY SKEWERS THE CHARGING SQUIRE. — 9

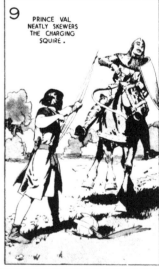

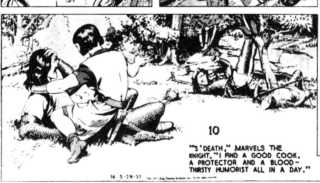

"S'DEATH," MARVELS THE KNIGHT, "I FIND A GOOD COOK, A PROTECTOR AND A BLOOD-THIRSTY HUMORIST ALL IN A DAY." — 10

16 3-29-37

NEXT WEEK: "THE DRAGON"

'ATTILA'
THE WILD HUNS
RAVAGE EUROPE
SAVE THIS STAMP

Prince Valiant

IN THE DAYS OF
KING ARTHUR
BY
HAROLD R FOSTER

433 A.D.
THULE REGAINED
SAVE THIS STAMP

SYNOPSIS: THE FRIAR UTTERS A FEW WORDS AND CLARIS IS NO LONGER A MENACE TO THE THRONE AND ALFRED BECOMES A MARRIED MAN ⋯ CUPID HAS MADE A SIMPERING IDIOT OF THE BOISTEROUS, TALL ROGUE WHOSE RINGING LAUGH AND CLASHING SWORD HAD KEPT THULE BUSY.

VAL IS DISGUSTED — A GOOD FIGHTING MAN HAS BEEN SPOILED TO MAKE JUST ANOTHER HUSBAND.

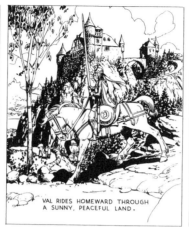

VAL RIDES HOMEWARD THROUGH A SUNNY, PEACEFUL LAND.

YES, A PEACEFUL LAND NOW ⋯ WHERE HEARTY YOUNG WARRIORS WEAR THEIR ARMOR ON A PEG.

FOR THE KING IS ALMOST TOO LENIENT FOR HIS TIMES AND ONLY ORDERS SUCH MURDERS AND EXECUTIONS AS ARE FOR THE PUBLIC GOOD, NEVER FOR PRIVATE PLEASURE — AND HIS PEOPLE GRUMBLE AT THE LACK OF ENTERTAINMENT.

EACH MORNING VAL TRAINS WITH THE OTHER KNIGHTS IN THE PALACE COURTYARD.

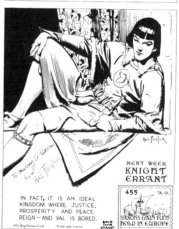

THE AFTERNOONS ARE SPENT MUCH AS HANDSOME PRINCES SPEND THEM EVERYWHERE.

ROME
SPQR
FEARS THE
COMING OF ATTILA

VAL'S EVENINGS ARE MOST INTERESTING, SCHOLARS, POETS, TRAVELERS AND PHILOSOPHERS GATHER IN HIS ROOMS FOR DISCUSSION AND HE LEARNS MANY CURIOUS THINGS.
SAVE THIS STAMP 112 - 4-2-39

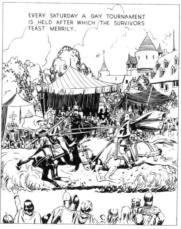

EVERY SATURDAY A GAY TOURNAMENT IS HELD AFTER WHICH THE SURVIVORS FEAST MERRILY.

NEXT WEEK
KNIGHT
ERRANT

IN FACT, IT IS AN IDEAL KINGDOM WHERE JUSTICE, PROSPERITY AND PEACE REIGN — AND VAL IS BORED.

455 A.D.
SAXONS GAIN FOOT-
HOLD IN EUROPE
SAVE THIS STAMP

THE TOTALLY GRAPHIC STORY

The graphic novel, as we know it today, consists of text, either narrative or dialogue (in balloons), integrated with sequentially deployed art. But early efforts in graphic narrative literature approached this form with an almost total elimination of words.

In Belgium, Frans Masereel, a skilled wood engraver, pioneered in the expansion of this art and employed it as a narrative tool.

In 1927, Masareel's *Die Sonne* was published in Germany. It consisted of sixty-three plates.

Masareel was joined by German artist Otto Nückel, whose wood engravings formed the basis of *Destiny*, a more ambitious work (approximately two hundred plates). This appeared in the United States about 1930.

The story here was more sophisticated and the graphic narrative more complex.

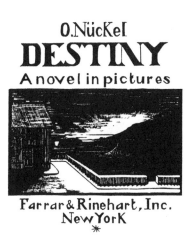

A study of the graphic novel form will reveal that a major burden of narration is assigned to the artwork. But with the proliferation of the comic book, the responsibility for the telling of the story is shared by text and image. The success of this mix of medium quickly succeeded and the totally graphic technique quickly gave way to the familiar graphic novel. A forerunner of the modern graphic novel is found in the work of Lynd Ward. He stands out as perhaps the most provocative graphic storyteller in the twentieth century.

Ward was a successful book illustrator famous for his brilliant woodcuts. In 1937 he published *Vertigo,* a graphic novel narrated entirely with wood-engraved images. Without a word of text he succeeds in telling a complete, compelling

story, thus proving the viability of the form. What is even more significant is that in over three hundred pages, *Vertigo*'s only concession to text is the occasional use of signs and posters. Ward kept the narrative focused by titling each chapter with a date. He used the entire page as a panel. Printed on only one side of the leaf, with each image floating in open space, he obliged the reader to turn a page in order to get to the next panel. This gave the reader time to dwell on each image and gave the storyteller total reader engagement.

Vertigo was printed as a conventional book and sold in book stores. It is interesting to note that this occurred about the time the first comic books appeared on newsstands. *Vertigo* was published by a mainstream publisher.

The story requires the reader to contribute dialogue and the intervening flow of action between pages. While this permutation succeeded in demonstrating the viability of graphic storytelling, to an audience alien to comics it could not go very far beyond simply breaking new ground. Many readers found this book difficult to read. Some enjoyed the magnificent effects of his woodcuts. But in the main, this experiment overlooked the reinforcement of a balanced mix of image and text. Ward was obviously not interested in accommodating the great dependence graphic storytelling has on a reader already conditioned to participating in the narrating process. The amount of action that transpires between these scenes takes considerable input from the reader to comprehend. There is a certain "visual literacy" that is second. For the practitioner (writer or artist), *Vertigo* can serve as a skeleton upon which to experiment with a story that has tighter graphic sequencing.

A STUDY OF THE GRAPHIC NOVEL FORM WILL REVEAL THAT A MAJOR BURDEN OF NARRATION IS ASSIGNED TO THE ARTWORK. BUT WITH THE PROLIFERATION OF THE COMIC BOOK, THE RESPONSIBILITY FOR THE TELLING OF THE STORY IS SHARED BY TEXT AND IMAGE.

THE GIRL

1929

CHAPTER 11

ARTISTIC STYLE AND STORYTELLING

Sooner or later, the subject (or question) of artistic style surfaces in relationship to the process of graphic storytelling. The ratio of its importance to other elements is arguable, but it is an inescapable ingredient. The reality is that artistic style tells story. Remember, this is a graphic medium and the reader absorbs mood and other abstracts through the artwork. Style of art not only connects the reader with the artist but it sets ambiance and has language value. Do not confuse technique with style. Many artists use crosshatch stippling, dry brush and wash the way a jazz musician might use riffs. Style, as we define it here, is the artwork's look and feel in service of its message.

Certain graphic stories are best told with a style appropriate to the content, and they often succeed or fail on that account. This is usually more of a problem for the artist than the writer, since it requires an artist to adopt a style appropriate to the story. There are some artists who can emulate almost any style, but this requires the discipline of a forger. Many contemporary artists engaged in graphic storytelling have an inherent artistic style compatible to content. Some are capable of mastering different styles to accommodate a story.

Moebius (Jean Giraud), for example, demonstrates a deliberate change of style for two totally different story missions:

BLUEBERRY (WESTERN) ARZAK (SCIENCE FICTION)

"THE READER ABSORBS MOOD AND OTHER ABSTRACTS THROUGH THE ARTWORK. STYLE OF ART NOT ONLY CONNECTS THE READER WITH THE ARTIST BUT IT SETS AMBIANCE AND HAS LANGUAGE VALUE."

BRYAN LEE O'MALLEY'S *SCOTT PILGRIM* USES A HIGH-OCTANE, *MANGA*-INSPIRED STYLE to relate the title character's quest to win the heart of Ramona Flowers. A loose and expressive brush line powers the soap/rock opera's story, which pits twenty-three-year-old Pilgrim against Ramona's seven evil ex-boyfriends. One look at O'Malley's endearing and sumptuous art and the reader is instantly bewitched into the story's spirited spell.

In *Maus*, Art Spiegelman worked in a style that, because of its character, delivered story. The overall look appropriately conveyed the impression that the artwork was created and smuggled out of a concentration camp. This is *graphic storytelling*.

In his illustrations for *Introduction to Kafka*, a graphic biography of the Czech author, Robert Crumb's natural style succeeds as a narrative.

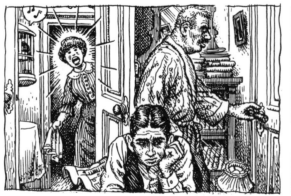

There is a psychic transmission present in the best graphic storytelling. It is generated by the storyteller's passion. It carries the story's emotional charge to the reader. A classic example of that is Al Capp's long-running satirical strip, *Li'l Abner*. One can "feel" the intensity and "hear" the laughter of the storyteller behind the art. In this segment of daily strips Capp keeps the high-voltage story going. The reader laughs even before ingesting the story, which in this example is quite thin.

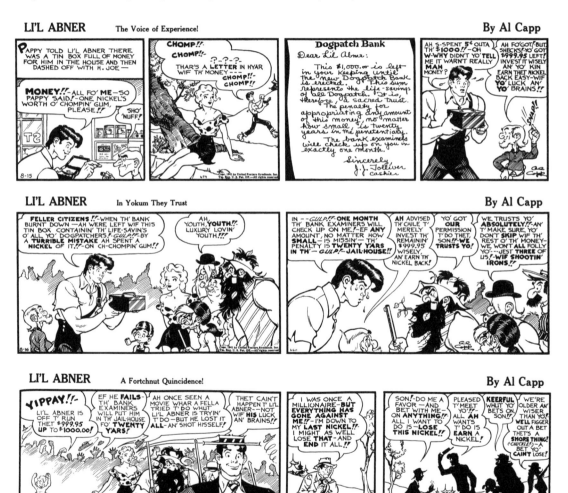

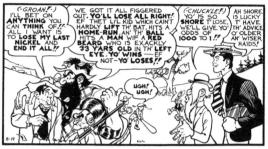

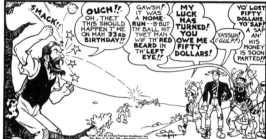

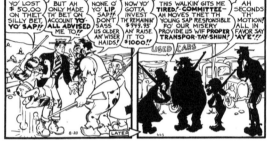

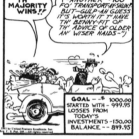

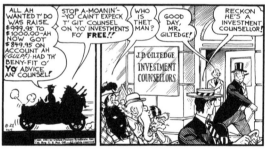

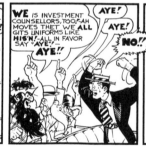

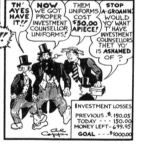

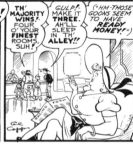

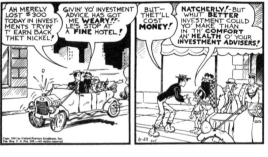

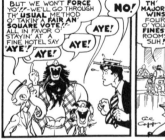

Graphic Storytelling and Visual Narrative

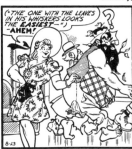
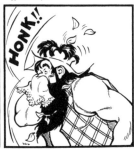
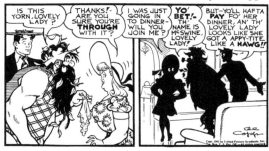

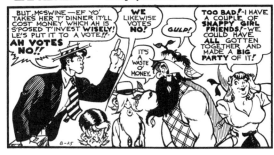
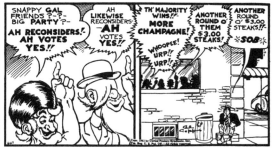

. . . AND THE STORYTELLER HIMSELF

Invariably, the storyteller becomes identified with and somehow part of the narrative. The uncontrollable elements in this otherwise disciplined medium, including style, selection of stereotypes, portrayal of violence, males and females, and the resolution of conflict, unmasks the storyteller. The responsibility for the selection of stereotypes, portrayal of violence and the resolution of conflict falls on the storyteller. Bias and values are revealed through the artwork because the "acting" of the participants in a story emanates from the artist's private memory of human behavior. Contriving the postures and gestures of a heartbroken character reacting to a great misfortune, for example, stems from inside the storyteller. The graphic storyteller has to be willing to expose himself emotionally.

> THE RESPONSIBILITY FOR THE SELECTION OF STEREOTYPES, PORTRAYAL OF VIOLENCE AND THE RESOLUTION OF CONFLICT FALLS ON THE STORYTELLER.

Sentimentalism, Schmaltz, Violence, and Pornography generally characterize a story and are ingredients under the storyteller's control.

- Sentiment is defined as an attitude resulting from feelings associated with emotion, idealism and nostalgia.
- Schmaltz stems from a Yiddish word for *oily* or *fat* and is associated in storytelling with exploitive emotionalism and excessive pathos.
- Violence portrays the act of physical struggle.
- Pornography, in graphic storytelling, can be defined as excessive exploitation of sexual activity to titillate.

Ultimately, storytellers have a responsibility not only to the reader but to themselves. Stories have influence. This imposes on the storyteller certain choices. What effect will the story have? Does the storyteller want to be identified with it? What are the limits of moral standards to which he will adhere?

THE MARKETPLACE

The graphic storyteller cannot escape the marketplace. A comic is essentially visual, which makes its package the product. The artwork influences the initial sale. This is not lost on the retailer and distributor, who are the final access to the reader. This encourages the creators to concentrate on form rather than content. The market, therefore, exercises a creative influence. The graphic storyteller, in pursuit of the market, will give sovereignty to the graphics. The graphic storyteller interested in the retention of readership will keep graphics in service to the story.

AND, FINALLY, THE FUTURE

Ultimately, the graphic storyteller must think about the future of his medium. An ever-advancing technology affects the communication environment.

A capsule history of transmitting graphics demonstrates the validity of this concern. The vehicles used have always been and still are in ceaseless evolution.

I propose, therefore, to conclude this examination of graphic storytelling by posing the following questions:

1. Over time, have the stories people tell been changed by the new methods of transmission?
2. What has been the role of the image in human communication?
3. How has changing technology affected underlying graphic storytelling skills?
4. How many of the classic vehicles of communication have disappeared as a result of advances in delivery?
5. How have the Internet and digital technology altered the audience?

These questions do not have simple answers, but thinking about them can help develop a working perspective that is an abiding necessity to a graphic storyteller.

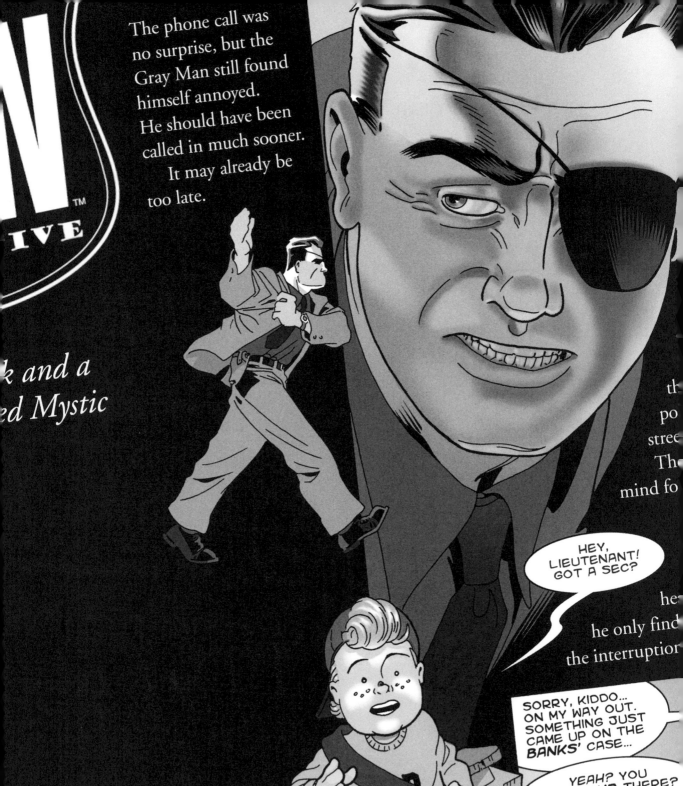

CHAPTER 12

COMICS AND THE INTERNET

The method of transmission has always had a critical influence on the creation of communication arts. Comics is a medium that is especially linked to its method of publication. As the ever-evolving vehicles of modern communication respond to social needs by accelerating the speed of delivery and the quality of imagery, it affects style, technique and reading rhythm of graphically told stories.

Digital technology has begun to compete with print, so mastery of this tool is now worth the creator's attention. With the advent of the personal computer and the growing culture of the Internet, readership has expanded. Online graphic storytelling or Webcomics have grown in importance on the Internet. Software, desktop scanners and the stylus are now essential tools alongside brushes, pens and ink. The essentials of storytelling, however, remain.

The reading convention of comics is similar in both print and digital formats. Sequential art should follow this discipline.

The vertical proportions of the traditionally printed comic book differ from the generally horizontal dimensions of a computer monitor. If a single page is required to fit onto the computer screen, reformatting is required to eliminate the need to scroll. Some storytellers forego the print medium completely, developing content specifically for the Web.

This decision affects clarity of artwork, legibility of lettering, typography and other production facets, until recently the sole domain of the printed comic book.

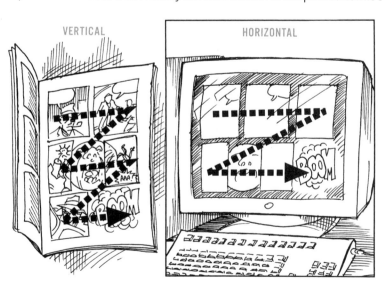

VERTICAL HORIZONTAL

DIGITAL TECHNOLOGY HAS BEGUN TO COMPETE WITH PRINT, SO MASTERY OF THIS TOOL IS NOW WORTH THE CREATOR'S ATTENTION.

THE INFINITE CANVAS

The infinite canvas allows the reader to follow the flow of imagery and text by scrolling across a larger field designed by the storyteller. This format offers a wide range of image deployment and panel layout, but also involves participation by the reader via navigation control.

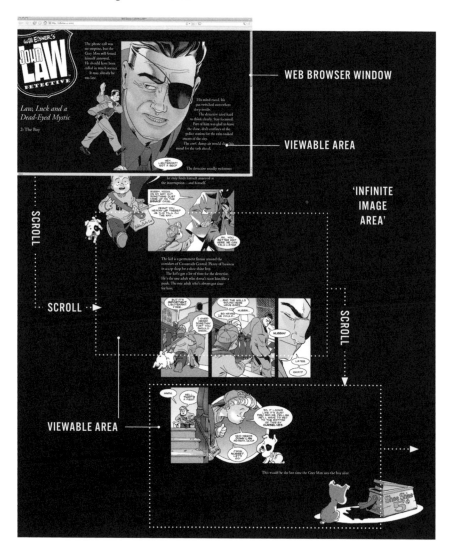

FURTHER INFORMATION ON WEBCOMICS

Webcomics have grown to be an important area for artistic expression on the Internet. Pioneers of online visual narrative have shown the creative potential of the Web, while commercial sites have succeeded in developing business models flexible enough to showcase the variety of Webcomic styles and delivery systems whilst satisfying reader and customer requirements.

The production of Webcomics takes a certain amount of technical knowledge concerning computers, graphic design software packages and how to "publish" your work online. While creators can do all of this themselves, there are also online communities and businesses that can assist at varying stages.

Artwork can be prepared for the Web in several ways: digitizing original artwork (pen and ink art, mixed media, etc.) or creating the artwork digitally using specialized software programs like Photoshop or Painter, or vector-based packages like Illustrator or Freehand. Other tools such as drawing tablets and flatbed scanners are also used.

All graphic files prepared for the Web should be 72 dots per inch (dpi), but as a general rule original art should be originally scanned at a higher resolution to maintain quality, then reduced to 72 dpi and optimized before uploading.

163

SUGGESTED METHODS FOR TRANSFERRING DRAWN ARTWORK TO A COMPUTER

For black and white artwork, scan at 800 dpi or more, Bitmap format, saving the file as a TIFF (Tagged Image File Format). This saves the art at high contrast, leaving only pure black or pure white pixels.

For graytone or colored art, scan at 300 dpi, in grayscale format for toned artwork (pencil, etc.) or RGB format for color art (gauche, watercolor, etc.), saving the file as a TIFF. This retains all graytone or color information.

Most coloring and adjustment of artwork is done using software programs like Photoshop or Fireworks. These programs can save your final files at 72 dpi in a variety of formats for viewing on the Web. The most common file formats are GIF (Graphics Interchange Format), JPEG (Joint Photographic Experts Group) and PNG (Portable Network Graphics).

These final graphics files, generally arranged using HTML (Hypertext Markup Language), will be the files uploaded to an FTP (File Transfer Protocol) site and made accessible via a Web browser, for example, Microsoft Internet Explorer, directed to a specific Web address or URL (Uniform Resource Locator)—for example, *www.willeisner.com*.

OBSERVATIONS ON STORY

It is not enough for one who undertakes storytelling in a graphic medium to allow the simplicity of technology and artwork to dominate. An underlying understanding of the philosophical terrain into which one ventures is useful when telling stories.

The following thinkers have contributed a body of useful reference to the art of graphic storytelling.

JOSEPH CAMPBELL Writing in *The Hero with a Thousand Faces,* Joseph Campbell comments on the nature and the story function of myths. He believes that myths are a nuclei out of which stories are fashioned. "Throughout the inhabited world, in all times and under every circumstance the myths of man have furnished; and they have been the living inspiration of whatever else may have appeared out of the activities of the human body and mind. It would not be too much to say that myth is the secret opening through which the inexhaustible energy of the cosmos pour into human cultural manifestation."

Campbell prefaces this by telling us that "shape-shifting stories, primitive or sophisticated, are marvelously constant....It is the business of mythology...and of the fairy tale to reveal the specific dangers...of the dark interior way from tragedy to comedy."

For the storyteller employing the hero to tell his stories, he advises, "the mighty hero of extraordinary powers...who is able to lift mountains and fill himself with terrible glory is each of us." Campbell also believes that "the usual adventure begins with someone from whom something was taken—or who feels that there is something lacking in the normal experiences permitted to the members of his society. This person then takes off on a series of adventures beyond the ordinary to recover what has been lost or to discover some life-giving elixir."

ROGER D. ABRAHAMS *African Folktales* by Roger D. Abrahams reminds us that Africa has had a long history of storytelling with imagery. This is related to graphics because sculptures, masks and postures in dance are used to accompany words and music to transmit the story. In this way, unaided by the easy availability of printing technology, the village historians, entertainers and philosophers dealt with tribal education and social conduct.

The author, a specialist in folklore, has some observations that are pertinent to the graphic storyteller. He believes, "The fable and its message are one. Stories operate like proverbs, as a means of depersonalizing, of universalizing, by couching the description of how specific people are acting in terms of how people have

always acted." Stories in tribal communities intend to reflect the agricultural environment. They are concerned with domestication of crops and cattle. Weather unreliability and scarcity of natural resources lead to hunger and disease so story-telling often reflects the importance of potency as a factor in the proliferation and survival of families. Social bonds are strained or broken by stealing of food or neglect of children in times of crisis. Therefore, he says, "no theme is more important or receives more attention than the building of families or friendship ties to provide that strength which in the face of natural disaster or perilous human responses to it, insures a community's survival."

The actors who people these stories are frequently animals whose characteristics are already familiar to their audience. Dramatizations, in dance or pantomime, employ imagery in which masks or costumes that portray animals serve as storytelling tools. As a result, "throughout Africa there are stories that *belong* to animals." Mice, hares, spiders and jackals are regarded as clever creatures and are featured in stories that attack or upset rules and boundaries of communal harmony. Such stories serve as an indirect and impersonal means of engaging in deep discussion.

LADISLAS SEGY Tribal storytelling often reaches beyond the oral and employs art as an accompaniment. African art is a very clear demonstration of functional imagery. When art is employed as a language, it submits to a discipline quite different, but related to primitive sculpture.

In *African Sculpture Speaks,* Ladislas Segy points out a relationship between art and story in primitive societies. "The African," he states, "lacking writing—carried his mythology—his literature—in his head, transmitting the legends orally from generation to generation. Sculpture was an additional language through which he expressed his inner life and communicated with the invisible world." Virtually every act in their lives had its ritual and every rite had its appropriate image. The art produced was more emotional in content than intellectual but was quite utilitarian, according to Segy. Because of the function of sculpture—particularly in masks used in a mime or dance—it related to known stories. Unlike the use of imagery in print, it was not part of a sequential series but rather contained the story in itself. This sculpture was "speaking in plastic language." The author attributes the focus of this art form (sculpture) to the lack of writing.

E. H. GOMBRICH In graphic storytelling, the quality of art is an unavoidable consideration. In *Art and Illusion,* E. H. Gombrich discusses some of the psychological considerations in the evaluation of artwork. He points to a common belief that artistic excellence is "identical with photographic accuracy." Thus, he claims, "aesthetics . . . has surrendered its claim to be concerned with the problems of

convincing representation, the problem of illusion in art." Referring to great masters of the past, who were both great artists and great illusionists, he further points out that the "history of representation became increasingly mixed up with the psychology of perception." He observes that the inability to copy nature stems from the inability to see it. He finds that "a figure drawn by one, ignorant of the structure of knitting of bones and anatomy, is different when compared to one who understands these thoroughly... both see the same life but with different eyes." The true miracle of the language of art, he tells us, is that it can teach us to see the visible world afresh and give us the illusion of looking into the invisible realms of the mind.

FURTHER READING

Understandably, the more recent emergence of the graphic dimension in modern storytelling has produced little in our libraries on this discipline. For the practitioner, however, the understanding of storytelling itself is worthy of study for it underlies and precedes the process of narration.

Roger D. Abrahams. *African Folk Tales*. New York: Pantheon Press, 1983.

Augusta Baker and Ellin Greene. *Storytelling: Art & Technique*. New York: Bowker, 1987.
(Storytelling as it is practiced in the United States.)

Joseph Campbell. *The Hero with a Thousand Faces*. Princeton, N.J.:
Princeton University Press, 1949.

E. H. Gombrich. *Art and Illusion*. Princeton, N.J.: Princeton University Press, 1960.

Norma J. Livo. *Storytelling: Process & Practice*. Littleton, Colo.: Libraries Unlimited, 1986.
(The art of storytelling.)

Scott McCloud. *Understanding Comics*. New York: HarperCollins, 1993.

Michael Roemer. *Telling Stories*. Lanham, Md.: Rowman & Littlefield, 1995.
(Narrative technique in storytelling.)

Ladislas Segy. *African Sculpture Speaks*. New York: Farrar, Straus & Giroux, 1952.

Mark B. Tappan and Martin J. Parker, editors. *Narrative and Storytelling: Implications for Understanding Moral Development*. San Francisco: Jossey-Bass, 1991.

SCHOOLS OFFERING COURSES IN COMICS CREATION

• Center for Cartoon Studies, White River Junction, VT
• Joe Kubert School of Cartoon and Graphic Art, Dover, NJ
• Rhode Island School of Design, Providence, RI
• Savannah College of Art and Design, Savannah, GA
• School of Visual Arts, New York, NY

NOTE: This list is by no means exhaustive, and is intended to be a starting point for those looking for information on comics instruction. The National Association of Comics Art Educators keeps an up-to-date list of schools and resources on its Web site at www.teachingcomics.org/links.php.

167

It is an ancient Mariner,
And he stoppeth one of three.
"By thy long grey beard and glittering eye,
Now wherefore stopp'st thou me?

The guests are met, the feast is set:
May'st hear the merry din."

He holds him with his glittering eye—
The wedding-guest stood still,
And listens like a three years' child:
The Mariner hath his will.

The wedding-guest sat on a stone:
He cannot choose but hear;
And thus spake on that ancient man,
The bright-eyed Mariner.

from "The Rime of the Ancient Mariner"
—Samuel Taylor Coleridge

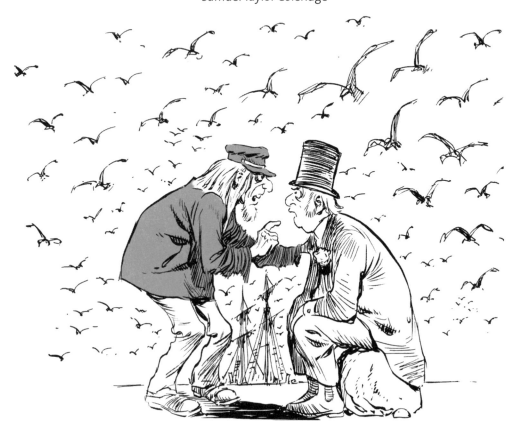

WILL EISNER (1917–2005) IS UNIVERSALLY ACKNOWLEDGED AS ONE OF THE GREAT masters of comic book art, beginning as a teenager during the birth of the comic book industry in the mid-1930s. After a successful career as a packager of comic books for various publishers, he created a groundbreaking weekly newspaper comic book insert, *The Spirit*, which was syndicated worldwide for a dozen years and influenced countless other cartoonists, including Frank Miller, who wrote and directed the major motion picture based on it. In 1952, Eisner devoted himself to the then still nascent field of educational comics. Among these projects was *P*S*, a monthly technical manual utilizing comics, published by the United States Army for over two decades, and comics-based teaching material for schools. In the mid-1970s, Eisner returned to his first love, storytelling with sequential art. In 1978, he wrote and drew the pioneering graphic novel *A Contract With God*. He went on to create another twenty celebrated graphic novels. The Eisners, the comics industry's annual awards for excellence (equivalent to the Oscars in film), are named in his honor.

ALSO AVAILABLE